PORTLAND
BEER STORIES

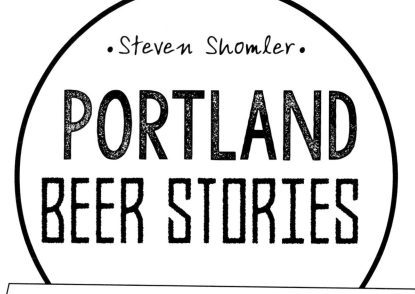

•Steven Shomler•

PORTLAND BEER STORIES

Behind the Scenes
with the City's Craft Brewers

AMERICAN PALATE

Published by American Palate

A Division of The History Press

Charleston, SC 29403

www.historypress.net

All images appear courtesy of the author.

First published 2015

Manufactured in the United States

ISBN 978.1.62619.899.9

Library of Congress Control Number: 2015937321

Notice: The information in this book is true and complete to the best of our knowledge. It is offered without guarantee on the part of the author or The History Press. The author and The History Press disclaim all liability in connection with the use of this book.

*This book is dedicated to all the craft brewers out there.
Thank you for making beer magic happen! You work harder than most people imagine, and you put your heart and soul into every tank, barrel, keg and glass.
Craft brewers are true culinary artisans. Cheers!*

CONTENTS

Foreword, by Jeff Alworth 11

Acknowledgements 13

Introduction 15

PART I: TEN PORTLAND BREWER STORIES: FROM A WRECKED CANOE TO GLUTEN FREE

Base Camp Brewing Company: "I Found My Calling to
Brew at a Winery" 19

Burnside Brewing Company: Making Beer Is the Best
Part of the Puzzle! 23

Breakside Brewery: Is Brewing a Job or a Profession? 25

Cascade Brewing: Barrel-Aged Sour Beers and So
Much More 28

The Commons Brewery: "I Put All of My Logic and
Common Sense Aside" 30

Beer Writer's Perspective: Brian Yaeger 33

Culmination Brewing Co.: The Intersection of Art and Science 35

Doomsday Brewing Co.: The End Is Near, Drink a Beer 38

Ecliptic Brewing: "This is Your Job. Go Get It!" 40

Gigantic Brewing Company: "We Are Oregon Brewers!
Come On!" 43

Contents

Ground Breaker Brewing: People Come in Here and Cry
Tears of Joy 45

Beer Writer's Perspective: Pete Dunlop 49

Part II: Six Portland Beer Stories: From Beer Bus to Beer Truck Driver
Ashley Rose Salvitti: From Portland Beer Fan to Businesswoman 51
Brian Butenschoen: One of the Best Job Titles in Portland 53
Bruce Wolf: He Grew Up on a Hop Farm 55
John DeBenedetti: Serving Brewers and Homebrewers for More
Than Forty Years 58
John Foyston: The Best of the Portland Beer Storytellers 60
Josh Huerta: "Is Rob Widmer Messing With Me?" 62

Beer Writer's Perspective: Ezra Johnson-Greenough 64

Part III: Road Trip!
Astoria: Fort George Brewery 67
Bend: Ale Apothecary 69
Hood River: Pfriem Family Brewers 73
Eugene: Ninkasi Brewing Company 76
Newport: Rogue Ales 80
Pacific City: Pelican Pub and Brewery 84
Port Townsend: Finnriver Farm and Cidery 88

Beer Writer's Perspective: D.J. Paul 93

Part IV: Cider
Bushwhacker Cider: America's First Cider Pub 95
Cider Riot!: Growing Up Drinking "Proper Cider" 97
Portland Cider Company: A Cider Love Story 99
Reverend Nat's Hard Cider: For the Sake of Cider 101

Beer Personality's Perspective: Chris Crabb 103
Beer Writer's Perspective: Wolf Linderman 105

Contents

Part V: Seven More Portland Beer Stories: From Homebrewing to Pink Boots

Lee Hedgmon: 2015 President of Oregon Brew Crew 107
Lisa Morrison: Portland's Own Beer Goddess 109
Rodney Kibzey: You Can Make Beer at Home? 111
Sarah Pederson: Escaping the Cubicle for a Much Better Life 114
Sean Campbell: Do Something You Enjoy With Your Life 116
Steve Woolard: "I Wanted Brewers in the Booth Telling Their Story" 118
Teri Fahrendorf: She Belongs in the Craft Beer Hall of Fame 120

Beer Writer's Perspective: Tim Hohl 124
Beer Writer's Perspective: Kris McDowell 126

Part VI: Ten More Portland Brewer Stories: From Barrel-Aged to Served With a Slice of Lemon

Hair of the Dog Brewing Co.: "I Thought That It Would Be Easy" 129
Kells Irish Pub and Brewery: First a Pub and Then, Twenty-Nine Years Later, a Brewery 132
Laurelwood Public House and Brewery: Because of a Call to Kurt Widmer 137
Lompoc Brewing: It Happened Over a Round of Golf 141
McMenamins: It's Been a Long Strange Trip 143

Beer Writer's Perspective: Christopher Pierce 147

Old Town Brewing: Keep an Eye on This Brewery 149
Sasquatch Brewing Co.: "Three Years Later, I Opened a Brewery" 152
StormBreaker Brewing: "I Will Wash Kegs Until You Make Me a Brewer" 155
Upright Brewing: "I Loved Brewing Even More Than I Thought" 158
Widmer Brothers Brewing: It's Pronounced "Hayfa-vy-tsen" 161

Appendix I. Other west Beer Books 165
Appendix II. Great Beer Places to Visit Checklist 167
Appendix III. Portland Beer Festivals and Events Checklist 169
About the Author 171

FOREWORD

What does a good beer city look like? For decades, municipalities large and small have argued the point, and no fewer than two dozen (by my rough count) have made a claim to be America's most beery. One of those cities was, of course, Portland, and I was happy to join the chorus. The problem is that few people have ever traveled broadly enough to actually assess these things. Portland seemed pretty darn beery, but I couldn't be sure.

A few years ago, I got the opportunity to travel for six weeks throughout beer's ancestral homelands in Britain, Belgium, Germany and the Czech Republic for a book I was writing. On that trip, I visited a lambic brewer who was pumping hot wort into the coolship above his brewery for an inoculation of wild yeast. In Yorkshire, I toured a five-story Victorian brewery where the coppers are still fired by coal and a cooper is on staff to make casks for the pub bitter.

In Plzeň, I sipped aging lager from a wooden cask in the cellars below the brewery that invented pilsner. In Kelheim, Bavaria, I chatted with a brewer in a room filled with open fermenters of burbling weissbier. These were beer cities. These were places where barley and hops were grown, where barley was malted, where brewers were professionally educated, where styles were born. For the first time, I knew what real beeriness looked like.

Do any American cities deserve to be mentioned in the company of these European giants? Not quite yet. Longevity matters, and only a completely blinkered booster would dare compare an American city with Munich or Brussels. But Portland comes very close.

FOREWORD

Like Munich, it has within a short drive all those classic hallmarks: local barley and hops, a local maltings and a professional brewing program. We also have one of two of the country's commercial yeast banks, the USDA research facility that gave us Cascade and Willamette hops, a number of the country's leading brewhouse manufacturers and, of course, the most breweries of any city on earth. Portland even has an unbroken history of brewing dating back to the 1850s.

None of that comes by chance. Brew by brew, truckload by truckload and pint by pint, thousands of people have built up all that infrastructure. I've often wondered how something like this happens. What is it with New Orleans and jazz or Kansas City and barbecue? Portland is certainly quirky and unique—it's not for nothing that we've got our own TV show satirizing this—but that doesn't explain the beer.

I think Steven Shomler must have asked himself these questions when he sat down to compile *Portland Beer Stories*. The answer lies in the people who built this industry and who are in the process of placing Portland's name next to London and Brussels and Munich. Their stories roll out in the following pages, and that answer emerges bit by bit as you read through the book.

It is a very exciting time to live in Portland. We're watching culture, of a kind that will be around for decades to come, being born before our eyes. This book is a document of the times—and I hope you have a chance to read and enjoy it.

—JEFF ALWORTH

Jeff Alworth is a writer living in Portland, Oregon. Jeff is the author of The Beer Bible: The Essential Beer Lover's Guide *(August 2015, Workman Publishing Company) and* Cider Made Simple: All About Your Favorite New Drink *(September 2015, Chronicle Books).*

Jeff can be found at his blog, Beervana, and All About Beer, *where he writes a weekly column. He is currently working on his next book,* Brewing the World's Classic Styles: Advice From the Pros, *from Storey Publishing.*

ACKNOWLEDGEMENTS

Many thanks to Ken Wilson, a true media maestro! Ken did a lot of driving for this book, especially for the road trip section. I did interviews and drank amazing beer as Ken drove us all over Portland and Oregon in his beloved Subaru Forrester. Ken also worked with me filming the video episodes of *Portland Beer Stories*, which are a perfect companion to the stories found in this volume.

I am very grateful to the wonderful Portland beer writers who graciously gave me a glimpse into their world and have allowed me to hang around and be a part of their community.

Thank you to Brian Yaeger. It is one thing to write one book. It is quite another to sit down and write a second. It is hard work to write a book, and when you are working on your second book, you begin to remember how hard it is. Brian is an accomplished author who knows that exact journey. Brian, thank you for the encouragement you gave me, especially down the home stretch, when finishing this book was feeling very daunting.

Thank you to three Zs—Zac, Zayne and Zoe. They have always been supportive of my goal to become an author and a speaker. I am very sorry that the beer that I regularly brought home from this project was not as pleasing to you as the food cart food from my previous book project.

Thank you to my friends and fellow dreamers in the Dream Stoker Nation community. The courageous way each of you battle for your dreams continually inspires me. Your presence in my journey has made this book possible. #DreamsDoComeTrue

ACKNOWLEDGEMENTS

Thank you to the fellow writers out there who have contacted me. It is very hard to be a writer, and the writing stories that you have shared with me have been a true blessing. If you are a writer, keep writing and telling your story. Write to make it happen—your writing can go from a spark to a bonfire! #BonfireWriter

Thank you to my fans! The messages and e-mails of encouragement you sent me as I worked on this project have been incredible. I am always humbled when someone wants me to sign one of my books or take a photo with me. I love meeting my fans, and I hope to meet more of you at the book signing events for this book.

Lastly, thank you to the people who agreed to be interviewed for this book and trusted me to tell their beer story. I love being a storyteller, and each of you has a story worth telling.

INTRODUCTION

WHAT'S IN THIS BOOK?

Within the pages of this book you find lots of stories: forty-four of them grouped into six sections. You will read about twenty Portland breweries and thirteen stories of people and enterprises that I feel are very important to the Portland beer scene. I have a road trip section with seven awesome cities worthy of a weekend-long visit. There is one brewer's story for each of the seven cities I highlight.

I also have the stories of four Portland cider makers. I know that cider is not beer, but some people consider craft cider to be craft beer's little sister and thus part of the family. Furthermore, most of the beer festivals that you attend in Oregon will likely have cider being poured and enjoyed. As John Foyston put it, "Portland, more than any other city in America, is leading the way in cider."

Throughout this book, you will also find insightful contributions from some wonderful Portland beer writers and beer personalities.

SCRATCHING THE SURFACE

I could have easily filled this book with in-depth stories of just five breweries, but I wanted to give you, the reader, a sense of the incredible diversity that we have in Portland among our breweries. I chose to go the

Introduction

route of painting with a broad brush so you could get to know a number of my beer heroes.

Please note that I was not able to include every story I wanted to. For example, the story of Hopworks Urban Brewery and its founder, Christian Ettinger, was one that I really wanted to tell, but I was not able to do so. Hopefully I will be able to include the story of Christian and his awesome Portland brewery in *Portland Beer Stories, Volume 2*.

Go on Your Beer Adventure!

I hope that this book inspires you to head out on your own beer adventure! In the back of this book is a checklist with the places and festivals highlighted in this book. When you visit one of them, you can check it off the list.

Get signatures! When you head out on beer adventures, take this book and a pen with you. If you happen to meet one of the people featured in this book, ask them to sign their chapter, hold up the book, take a photo with them and send a tweet or make an Instagram or Facebook post. Have fun with it! The hashtag for this book is #PortlandBeerStories

What Is Beer?

There are two correct answers to that question. The first answer I learned from Teri Fahrendorf, and the second answer I have learned from living in Portland since 2004.

The first answer: beer is a fermenting or fermented grain beverage.

So how is beer made? Please keep in mind that just like there are a number of ways to skin a cat, there are a number of ways to make beer. Here is a thumbnail sketch of how beer is made. This a *very* basic explanation. To get a more in-depth explanation, talk with any local brewer or homebrewer. I have found that brewers love to talk about how they make beer, and each one seems to have a slightly different approach.

To make beer, water and malted barley are added to a mash tun, and they sit in the mash tun for about an hour. Then the water is strained off. Part of this straining process includes sprinkling water over the wet malted barley, and that process is called sparging. Some brewers do this straining in their

mash tun, and some brewers use what is called a lauter tun. The goal is to separate the liquid from the grain or malted barley. What you end up with is like a barley tea, and that liquid is called sweet wort. Sweet wort does not yet have hops added to it.

The sweet wort is added to a kettle, where the wort is boiled. Once it begins to boil, hops are added for flavor. Now you have bitter wort. The wort boils for about ninety minutes. Sometimes, toward the end of the boiling time, additional hops are added to the wort for aroma.

The hot wort is then passed through a heat exchanger, where it cools down, and is moved into a fermenter. At that point, yeast is added to the now cooled down wort. When brewers add the yeast to the wort, they say they "pitch" the yeast. Now the fermenting process begins. The liquid, basically a very young beer, stays in a fermenter for between seventeen and twenty-one days.

From there beer is often moved to a brite tank to be held until it is put into a keg or bottled or canned. Sometimes brews go from a fermenter to a barrel, where the beer will be aged.

The second answer? Beer is community. I have seen this over and over again since I moved to Portland. People make beer together, and they gather in homebrew clubs like the Oregon Brew Crew to talk with one another about how they make beer. People drink beer together. Go to any Portland brewpub or beer bar, and you will see people meeting up with friends to share a pint and enjoy one another's company. The power of beer to facilitate community is quite fascinating. I can't explain it, but I have definitely observed it over and over again.

The same holds true for the brewers here in Portland and across the Pacific Northwest. The Portland brewing "community" is a very real thing. By and large, here in Portland our brewers are *very* supportive of one another. I can't tell you how many times I have been at a brewery and another brewer will stop by with a word of encouragement.

Beer is one of the things that make Portland such a special city, and we are very lucky and blessed to have the beer culture that we do.

My Beer Story

When I was growing up, my dad drank a lot of beer. He was always looking for the cheapest twelve-packs that he could find. He often would be drinking Falstaff or Old Milwaukee. I can still remember the bright red Old

Introduction

Milwaukee cans. My dad was an Orange Country deputy sheriff, and I grew up in Southern California on 260 acres in the hills off El Toro Road between Lake Elsinore and Perris. It took nine miles of dirt road to get to our place.

What I loved most about my dad drinking beer was that every so often his friends on the force would make the trek to our place. They would drink beer, and later in the day, we got to set up the empty beer cans on a hillside and go "plinkin.'" They would take out their guns and shoot the cans down. As a young kid, getting to stack up the cans in small three-can towers and watch them get knocked down was always a blast.

Sometimes I got to shoot at the cans. I discovered if you missed low, the dirt would spray up, and the cans would still fall over. Through all of my growing-up years, the liquid inside those beer cans held no interest. As far I could tell, the stuff in those cans tasted like cold horse urine. Even when I was teenager, beer held no interest.

In 2004, I moved to Portland, where I first began drinking beer. Prior to moving here, I rarely had a beer and I did not know much about it. I had been living in Portland for a few years when I went to the Mall 205 McMenamins and ordered a Terminator from Jim, one of the servers there. Somewhere along the way, I had gotten it in my head that I only liked dark beers, so it seemed like a good beer to order. Wow! That Terminator was awesome! My craft beer journey had begun. I began going to my local McMenamins on a regular basis, and Jim was often my server. Over time, he did a great job explaining the beer world to me. Jim was always willing to answer my questions and bring me a taste of something new to me that they had on tap.

I still remember the day that I discovered what a "nitro" beer really was. For some reason, I thought that nitro beer was something really, really strong.

Over the past seven years or so, I have fallen in love with craft beer, and I have discovered that there are many, many different styles of beer that I enjoy. I have a great time finding my way through beer, and I am delighted that I have been able to write this book and share the stories of the amazing people who make beer magic happen here in Portland.

TEN PORTLAND BREWER STORIES

FROM A WRECKED CANOE TO GLUTEN FREE

· BASE CAMP BREWING COMPANY ·

"I Found My Calling to Brew at a Winery"

Justin Fay and Joseph Dallas opened Base Camp Brewing Company on November 2, 2012. Not only are they family, they also work very well together and have built a phenomenal brewery. Here is how Base Camp Brewing Company came to be.

Justin Fay was talking pre-med classes at Oregon State University. He has always wanted to be self-employed, and he was on track to open his own medical practice. Things changed in 2005 when he got a summer job at King Estate Winery. It was there that Justin found his calling to brew beer.

As soon as Justin started working at King Estate Winery, he was captivated with the idea of fermentation. The idea that you could make something like wine or beer with your own hands enchanted him. Justin began reading about fermentation, making wine, brewing beer and distilling spirits. The more he read about brewing beer, the more than he knew that brewing was his destiny.

For Justin, brewing brought together all of his passions. To be a brewer, a person would use creativity, engineering and design and work physically with his or her hands. When Justin got back to school that fall, he changed his major to fermentation science and set out on a brand-new direction for his life.

Justin Fay, founder and brewmaster of Base Camp Brewing.

Justin also immediately began homebrewing, and the first couple beers he made were awful—but even that fired him up. Justin said to himself, "It's on! I am going to figure this out." Figure it out he did. Just a year later, in 2006, Justin became a brewer at Klamath Basin Brewing, where his beer won a number of awards.

In the summer of 2011, Justin and Joseph got the keys to the building in Portland that is the current home of Base Camp Brewing Company. The remodel of the building and the set up of their brewery took a year and half, and they finally opened Base Camp on November 2, 2012.

S'more Stout

I first heard about this beer at the Sugar Shop Food Cart. You can find the Sugar Shop story in my first book, *Portland Food Cart Stories*. One day, Shannon, owner of the Sugar Shop, made some ice cream made with this glorious beer, and I got to have some. Having thoroughly enjoyed ice cream made with S'more Stout, I headed over to Base Camp to try the beer itself! I fell in love with it!

Justin wanted to make a beer that evoked the flavors of one of his camping favorites: s'mores. He wanted a beer that was reminiscent of chocolate, marshmallow and graham cracker. He also wanted to do this using *only* malt and hops.

Time for a brief tangent—the taproom at Base Camp is a great place to have a beer and a meal. Base Camp has a rotating selection of food carts sitting in front of its building that serve as the kitchen. You go can up to the bar in the Base Camp taproom, open the menu, pick out what you want to eat, place your order and the food will be brought to your table.

S'more Stout from Base Camp Brewing.

Base Camp has a camping/outdoor theme, and it has some really cool fire tables outside. The only food item that you can buy off the menu that comes from Base Camp itself and not a food cart is s'mores. You get marshmallows, a roasting stick, graham crackers and chocolate. This fun treat has been on the Base Camp menu since day one.

Back to the S'more Stout—Justin worked for months trying to make a beer that tasted liked chocolate, marshmallow and graham cracker. On November 1, 2012, the beer still was not right. It was lacking the toasted marshmallow flavor. Justin was desperate, as the brewery was opening the next day.

Given the deadline that he was up against, Justin was willing let go of a little bit of his Reinheitsgebot ideal. Earlier that day, Justin had seen a bag of marshmallows at the bar. Remembering this, he got an idea. He went to the back, got a hand-held blowtorch, stuck a marshmallow on the side of the glass, toasted that marshmallow and added the S'More Stout. A Base Camp classic was born.

Old Blue from Base Camp Brewing.

Old Blue

Like most things in the Base Camp taproom, that canoe you see hanging above the bar has a great story. It was a family canoe that saw many trips, and it even had a name: Old Blue. In the spring of 2012, Justin and some friends took that canoe down the Wilson River, out toward Tillamook. The water was running very high, so they were only going to do the rapids on the upper reaches of the river.

As they came to the last rapid, there were two logs jammed together in the middle of the river, forming an X. These logs sank Old Blue, and it remained at the bottom of the river for three weeks. Finally, the water went down enough that Justin and his friends were able to fish out the canoe.

Sadly, Old Blue was ruined, and Justin's dad was none too pleased. Justin hauled Old Blue back to the brewery, thinking that maybe they would hang it up in the taproom. Now you know.

• BURNSIDE BREWING COMPANY •

Making Beer Is the Best Part of the Puzzle!

It is one thing to be able to brew beer, but it is quite another to be able to start and run a brewery. As I interviewed brewers for this book, I heard over and over again how much the business side of brewing matters. It is a puzzle with a lot of pieces. Jason McAdam is one of the co-founders of Burnside Brewing Company, and he knows how to work that puzzle.

Jason's beer journey started when he was eighteen and he was given a homebrewing kit as a gift. Jason fell in love with brewing, and he had been brewing ever since. Jason went "pro" in 1998 when he became a brewer at the McMenamins Oak Hills Brewpub. Jason spent more than six years brewing for McMenamins; his stops included Edgefield, Hillsdale and the Crystal Ballroom.

At McMenamins, Jason not only began brewing, but he also learned a tremendous amount about what it takes to make the business side of a brewery succeed. "Not only are you responsible for your brewery—beer costs, labor costs and production—you have to take care of your brewpub and make sure that they don't run out of beer and keep them supplied with an appealing beer selection," he explained.

In 2005, Jason opened Roots Organic Brewing with Craig Nicholls and spent five years there before leaving to open Burnside. Jason signed the lease for the building in May 2010 and opened Burnside on December 28, 2010.

Naming a Brewery: Tougher Than You Realize

Jason had intended to go with the name Alchemy Brewing. One of the tough things that someone starting a brewery runs into is that there are lots and lots of other breweries, wineries and distilleries out there that may already be using the name the would-be brewer has picked. That very thing happened to Jason when the name Alchemy was already being used.

As crazy as it sounds, Portland is divided into five quadrants. It is split east and west by the Willamette River and north and south by Burnside Street. Hence, we have Northeast Portland, Southeast Portland, Southwest Portland and Northwest Portland. Once we get to the Lompoc chapter, we will talk more about the Fifth Quadrant. As you can see, Burnside Street is a very important one in Portland.

Jason McAdam, brewmaster and co-founder of Burnside Brewing.

With the Alchemy name or not, Jason was going to open a brewery. In fact, the lease had been signed for the space, and Jason's brewery still did not have a name. As fate would have it, the space Jason found was on Burnside, an iconic street in Portland. Someone suggested the name Burnside Brewing, and it stuck. It is an iconic name that Burnside Brewing has more than lived up to.

The Beer

Burnside has a number of excellent perennial beers that are generally always on tap, including Burnside Stout, Sweet Heat (a favorite of mine), Burnside IPA and Oatmeal Pale Ale. It also does many terrific seasonal beers.

Burnside currently has four recurring seasonal beers, and I love all four of them: Permafrost, Spring Rye, Lime Kolsch and The Dapper Skeleton, a delightful beer made with pumpkin, three different chilis, cherrywood smoked malt and coca nibs. Whenever you go to Burnside, plan on having at least two beers, and make sure that a seasonal is at least one those two beers.

The Portand Fruit Beer Festival

Portland is home to a number of amazing beer festivals, and one of my personal favorites is the Portland Fruit Beer Festival that Burnside puts on each year in June. Each year, brewers from the Northwest and across the country brew beer specifically for this event.

The 2014 Fruit Beer Fest had over thirty different fruits represented and over fifty different fruit beers. This event currently takes place at Burnside Brewing, but I will not be surprised if someday this very popular festival moves to a larger venue.

I Still Think About That Duck Fat Burger

From the beginning, Jason wanted to have very good food served at his brewpub, and the food at Burnside is amazing! Almost everything about the menu is fantastic. My only complaint is that the duck fat burger is seasonal. Both myself and fellow author Brian Yaeger want the duck fat burger made a permanent part of the menu. I had one of these exquisite burgers following the 2014 Fruit Beer Festival Media Preview, and to this day, I still think about that burger. Burnside is one of the breweries featured in *Portland Beer Stories* where I highly recommend you enjoy both a beer and a meal.

Seeing his dream come true together and seeing his brewery succeed has a been a thrill for Jason, and to this day, for him, the best part of the puzzle that is running a brewery is making beer.

• BREAKSIDE BREWERY •

Is Brewing a Job or a Profession?

Breakside opened the doors of its Dekum Pub in May 2010, and it has been rapidly growing ever since. In January 2013, it opened a thirty-barrel production facility and tasting room in Milwaukie, Oregon, a city just south of Portland.

In my opinion, Ben Edmunds, the founding brewmaster, has a lot to do with that growth. Ben grew up in Detroit, Michigan. He went to college at

Ben Edmunds from Breakside Brewing.

Yale, where he majored in Spanish, focusing on Latin American literature. In 2004, following college, Ben moved to Leadville, Colorado, and became a high school Spanish teacher.

Up to this point, Ben's journey did not seem to be headed in the direction of becoming a brewmaster. However, that is the awesome thing about the Portland beer community: regardless of your background, if you want to be a part of it and you are willing to do the work, there is a place for you here.

Ben did do a little homebrewing while in college, and when he got to Colorado, he became very interested in craft beer. To quote him, Ben became a "beer geek" and an avid homebrewer. In 2008, he was ready to make some changes in his life. It was time for him to leave Leadville. I have been told that when someone leaves a Colorado mountain town, they don't move to Denver. That was certainly true for Ben.

Ben checked out a number of West Coast cities, including Portland, San Francisco and Seattle, as well as Boise, Idaho. Portland was the winner, and in August 2008, Ben moved here. He did not know yet what he wanted to do for work, but the possibility of becoming a brewer was in the back of his mind. Over the next year, Ben worked for Lewis and Clark College and the Jewish Community Center.

Chicago and Germany

In August 2009, Ben decided that he was going to become a brewer. At this point, some people might have decided to get an entry-level job at a brewery and work their way up the ladder. Ben decided to attend the Siebel Institute of Technology, or simply Seibel, as it is referred to in the beer world. Seibel is the oldest brewing school in North America. Its flagship course is a twenty-week program that has students studying brewing in Chicago, Illinois, and Munich, Germany.

There are number of ways to become a brewer. If one of my kids wanted to become a brewer, I would encourage him or her to first get a three-month internship at a brewery to make sure that he really wanted to be a commercial brewer. Just because you like beer or like homebrewing does not mean than you are going to enjoy being a commercial brewer.

If one of my sons or daughters did that and they still wanted to be a brewer, I would tell them to attend the twenty-week WBA Master Brewer Program at Siebel. This assumes they want to be a professional brewer and not just have a job in brewing. The difference is vast.

Is Brewing a Job or a Profession?

The answer is "yes." Brewing can be a job, or it can be a profession. By and large, the difference is how you approach it. Talk to Ben Edmunds and listen carefully. From the moment he decided to become a brewer, he approached it like it was his profession. Case in point: during our interview for this book, Ben talked about the core values and ethos at Breakside and his role in ensuring that those core values were lived out. I have not heard those kinds of things from very many brewers.

Ben was at Siebel from August 2009 to January 2010. When his time studying at Siebel was complete, Ben returned to Portland. Shortly thereafter, a mutual friend put him in touch with Scott Lawrence, who was opening Breakside and needed a brewmaster to run his brewery. Ben was looking for a job working in a brewery, and the rest is history.

The Name

The name "Breakside" is an ultimate Frisbee reference. In the game of ultimate Frisbee, the "break side" is the side that the defense is trying to prevent you from throwing to. If you can make a pass to the break side, you are making a play that will change the game to your team's advantage.

When Breakside hired Ben Edmunds, it definitely made a play to the break side.

· CASCADE BREWING ·

Barrel-Aged Sour Beers and So Much More

Art Larrance may be the most legendary of the Portland beer pioneers, and that is saying a lot. Today, Art spends his workweek alongside Ron Gansberg, the brewmaster for Cascade Brewing. They are leading the way in barrel-aged sour beers. Art has played a huge part in Portland beer history, but when you talk with him, he is very excited about the future that he and Ron are building at Cascade Brewing.

Art's beer story began in the late '70s when he started homebrewing. Back then, he would go to FH Steinbart to get his malt extract. In the early '80s, he began asking why there wasn't a brewery in Portland. He then set out to change that, and in 1986, he was one of the co-founders of Portland Brewing.

Great minds tend to think alike, and by the time Portland Brewing was launched, it was the fourth Portland-area brewery to open in that general time frame. The others were Bridgeport, Widmer and the McMenamins Hillsdale Brewpub.

In 1994, Art was asked to leave the company he had founded, but he told me that this was the best thing that ever happened to him. A year later, in 1995, he was securing the property for Cascade Brewing, which opened in December 1998. Many people would have been crushed after being pushed out of their own company. However, Art is a special person, and he took that body blow and just kept going. Very impressive.

Art is also the founder of the Oregon Brewers Festival, or "OBF," as it is know in the Portland beer community. It is my opinion that the OBF has helped to put Portland on the global beer map as much as anything else.

Art Larrance and Ron Gansberg from Cascade Brewing.

The numbers speak for themselves: in 2014, over eighty thousand people attended the OBF over its five-day run, and the economic impact of the 2014 OBF on the Portland economy was over $32 million.

When the Portland brewing scene was just starting, people would be inspired by imported beer from places like Germany and Belgium. The thinking was that if they could make great tasting beer over there in Europe, the same could be done in Portland.

Today, young brewers in places like Belgium and Germany hear about the OBF, and they begin researching the Portland beer community. They start to believe that if those brewers there in Portland can start their own craft breweries, they can do the same thing in Europe. Art actually hears from brewers overseas who think that very thing.

Ron Gansberg: A Brewing Genius

Ron Gansberg, brewmaster of Cascade Brewing, says that his beer journey started when he was twelve years old. That is when he began making root beer in the kitchen sink and carbonating it with yeast. By his late teens, he was homebrewing beer. When Ron was twenty-five years old, he left his

hometown of Klamath Falls and moved to Portland in pursuit of a gal who later became his wife.

Ron worked a couple different jobs for two years when he got to Portland, and in 1986, he became a brewer at Bridgeport. He eventually became the engineer manager overseeing the brewing operations. In 1993, Ron left Bridgeport and took the same position at Portland Brewing.

In the summer of 1997, Art invited Ron to be a part of Cascade Brewing. Ron joined the team just as they were breaking ground on their first location in Southwest Portland, the Raccoon Lodge and Brew Pub. Ron became the founding brewmaster. In 2010, Ron oversaw the opening of the Cascade Brewing Barrel House, aka the House of Sour.

Sour Beers—Just Try One

Cascade Brewing has a stunning array of great sour beers. Last summer I was between appointments one warm Saturday afternoon, and I stopped at the Barrel House for a forty-five-minute break. I was going to sit in the sun, have lunch and enjoy a sour beer. For lunch, I had a Dungeness crab roll, and the sour beer that I had was a Candied Cantaloupe. Oh man, was that a good beer! Perfect for a warm sunny Portland day.

Do yourself a favor, and make it point to head over to one of the two Cascade Brewing locations and order a sour beer. You might be surprised at how good it is!

· THE COMMONS BREWERY ·

"I Put All of My Logic and Common Sense Aside"

The Commons Brewery opened up on SE 10th Avenue and SE Stephens Street in the fall of 2011, and in the spring of 2015, it moved to a larger facility on SE 7th Avenue and SE Belmont Street. This very successful Portland brewery is anything but common.

The Brewery That Started in a Garage in Southeast Portland

Mike Wright had homebrewed for seven years when he decided to see if he could get his garage licensed as a production brewery. At the time, he had a fifteen-gallon system. By the summer of 2010, Beetje Brewery was a real, legal entity, blessed by the Oregon Liquor Control Commission (OLCC) and the federal Alcohol and Tobacco Tax and Trade Bureau (TTB). Beetje is Flemish for "little bit." Prior to 2010, Mike had been introduced to Belgian beers through family members, and he loved them.

In the summer of 2010, Mike submitted a beer to the Oregon Brewers Guild event Cheers to Belgian Beers that was very well received. Mike was then invited by Angelo M. De Ieso II to submit a beer to Brewpublic's Microhopic II festival happening at Bailey's Taproom. Mike brewed a beer called Urban Farmhouse and kegs of that beer were sold to Bailey's for this event, and people loved it. To this day, Urban Farmhouse is one of the Commons' most popular beers.

By the fall of 2010, Mike had a few customers who were putting his beer on tap, including Victory Bar, Hawthorne Hophouse and Saraveza. By the winter of 2010, Mike had upgraded to a forty-gallon system, but he realized that this was really an overgrown hobby and not a viable business model.

Mike ran a bunch of spreadsheets and considered whether or not he should open a commercial brewery. All of his analysis said no, he should not. But, according to Mike, "I put all of my logic and common sense aside and decided to do it anyway." Mike was working a full-time job as an IT project manager, and the idea of no longer working "for the man" and being fully self-employed really appealed to him.

In the fall of 2011, Beetje Brewery became the

Mike Wright, founder of the Commons Brewery.

31

Commons Brewery, and Mike began to work eighty to ninety hours a week. He would work his day job for forty hours and also work at the brewery for another forty or fifty hours. He did this in 2011 and 2012. Finally, in September 2013, Mike was able to quit his day job. Mike's dream of being self-employed has come true, and he is well on his way to having a very successful business.

Early on, Mike faced two big challenges. First, he had no commercial brewing experience, and there was mountain of daily production things that he had to learn. The second challenge was that he discovered that building out a brewery is essentially building a small manufacturing facility, and with that came another steep learning curve.

The Beer

At the Commons, there are only two year-round beers: Urban Farmhouse and Flemish Kiss. The rest of the beers it brews are rotating, seasonals or one-offs. One of my two favorite Commons beers is Myrtle. To me, this is the perfect beer for brunch at Gigi's Café, where they serve authentic Liège-style waffles. I also love the Bourbon Little Brother, a wonderful barrel-aged beer.

One of the most uncommon things about the Commons Brewery is that it is one of a handful of Oregon breweries that doesn't make an IPA. I am pretty certain that it never will.

The Name

Mike named his brewery the Commons because he wanted to invoke the idea that his beers are accessible and that they facilitate community. As they say at the Commons, gather round beer.

Beer Writer's Perspective
Brian Yaeger

Brian Yaeger is the author of the comprehensive guidebook Oregon Breweries *and* Red, White, and Brew: An American Beer Odyssey. *He is frequently published in* All About Beer, Draft Magazine *and* Portland Monthly. *He runs Inn Beervana Bed & Beer in Portland along with his wife, Half Pint; son IPYae; and dog Dunkel.*

That Portland has more breweries than any other city on Earth is a well-known fact, but if there's one thing craft beer lovers agree on, it's that what we love about craft beer is quality, not quantity. I vote we change the conversation to tout that Portland has the highest-quality beers, pint for pint, on the planet.

That may sound sacrilegious to our friends down south in California who excel at West Coast IPAs, but Portland is no one-hop pony, and so our Northwest IPAs encompass a wide spectrum of the hop rainbow. The cries of Belgian ale aficionados are probably echoing through their abbeys, but in and around Beervana, Belgian-style beers receive their due reverence. In fact, thirsty visitors will find that some breweries such as Breakside and Widmer Brothers produce an incredibly wide range of beers and do them exceptionally well, while others specialize, like Occidental's German lagers, the Commons' urban-rustic saisons and Cascade's puckering sour ales. Heck, tucked inside the Green Dragon Pub you'll find the tiny Buckman Botanical Brewery, which, as the name alludes to, looks to teas and other botanicals—*gasp*—in lieu of hops.

Portlanders love beer, but we love it discerningly. We love variety, but we love craftsmanship more. We love exploring global flavors, but at heart we're locavores. (Good thing hops grow locally in the Willamette Valley.) Marry those two concepts and you'll get what Portlanders love the most: quality breweries in each of our respective neighborhoods. You see, breweries belong to a neighborhood, but not the other way around; neighborhoods rejoice when a new brewpub opens up. And if a new brewing company arrives in the form of a nanobrewery, one too small to include a pub or possibly even its own tasting room, locals head to their nearest craft-centric taproom in hopes of finding a pint or tulip glass to try.

Here I'll use an analogy I once told Steven, which, given his first book—*Portland Food Cart Stories*—he seemed to dig. Basically, oxymoronically, nanobrewers are like professional homebrewers. The cost of launching a

nanobrewery fairly resembles that of the beloved food carts that drive (sorry) the craft of the comfort food industry. And we love us some food trucks. I think if most food cart operators are honest, they'd rather have a brick and mortar (see: Lardo, Shut Up and Eat, Cultured Caveman, etc.) Same goes for nanobrewers. It's an iffy business model if their goal is to quit their day job. Luckily, with good recipes and business acumen, Beetje Brewing expanded to become the Commons (one of Portland's most celebrated breweries) and even the guys at Vertigo in Hillsboro successfully transitioned from their lucrative careers at Intel.

At the beginning of 2015, there are over eight hundred food trucks in Multnomah County and over eighty breweries in the Portland metro area. I cringe when I hear someone use the word "saturation" or hear someone ask, "Do we really need another brewery?" My friend, it's not about need. We need a roof over our heads, hoodies to keep the rain off our heads when we're frequently outside and food in our bellies (preferably gourmet tater tots or mac'n'cheese, according to menus). If beer were simply a commodity, we'd only need two or three gargantuan, industrial beer factories to service everyone. From here I hear you shouting, "No, I *need* craft beer," but I'd counter that you *want* craft beer because flavor matters, provenance matters, and supporting the people responsible for providing you with it is important.

To get your fill, beyond the brewery's pubs and tasting rooms, there are numerous, excellent taphouses and public houses specializing in local suds. I like the corner of SE Division and 12th Avenue where the fifty-tap Apex and bottle emporium BeerMongers exist catty-corner from each other. I love that Belmont Station has one of the best if not the best bottle selections in town and recently expanded the back patio for more capacity for its Beer Café. And any time I find myself in North Portland, I have to flip a coin to decide if I turn right off I-5 to visit Saraveza (great pasties) or bank west off the freeway for the Hop & Vine (one of Portland's best burgers). Some people think they can "do" a Portland beercation in a weekend. That's such a tiny tip of the iceberg that it couldn't take down a paddleboat. For a titanic exploration of Beervana, you'd need at least a week. Or just do like the rest of us and move here. Especially if you're thinking of opening a brewery.

· CULMINATION BREWING CO. ·

The Intersection of Art and Science

Tomas Sluiter is finally realizing a long-held dream to own his own brewery, and it is his goal to have Culmination be known as a place that has great food, great beer and great music. Here is his story.

Tomas grew up in Grand Rapids, Michigan, and he began homebrewing when he was seventeen years old. In 1999, he was working the technical side of the local evening newscast. Tomas began to think that if he did not leave Grand Rapids soon, he never would. In December 1999, he and his fiancé, April (now his wife), began a forty-day road trip to check out other parts of the country and see if one those places might feel like home.

On that road trip, they visited places such as Austin, Atlanta, Santa Fe and Nashville. As they were heading west, they hit an ice storm in Oklahoma, and they parked their car and flew to Los Angeles. That detour meant that they missed seeing Portland, a city on their list of possible places to relocate.

In the summer of 2000, Tomas and April visited Portland, and they knew right away that it was what they had been looking for. Portland hit all of their buttons: the food, the beer, the outdoors, the music and the people. By 2001, they had moved to the Rose City.

Tomas began applying for jobs in television, and he also applied for an assistant brewer job. He was offered the assistant brewer position at Old Market Pub and Brewery in Southwest Portland, and he took it. He was now on a whole new career path. A few months later, he became head brewer. Along the way, Tomas oversaw a significant expansion, and under his guidance, the brewery went from about 250 barrels each year to around 1,000 barrels a year.

In early 2013, Tomas left Old Market and began the journey of opening his own brewery. This journey had a number of ups and downs, including having to leave the "perfect building" after construction had already begun due to unforeseen structural issues.

Thankfully, Tomas was able to find a building just off of NE 22nd Avenue and NE Sandy Avenue. With an opening date of May 2015, Culmination Brewing Co. is the youngest brewery in *Portland Beer Stories*. It also happens to be one of the most innovative small breweries in Portland.

A Steam-Heated, Five-Vessel, Semiautomatic System

Small breweries typically have a two-vessel system. Tomas has designed Culmination with five vessels: a mash tun, an adjunct cooker (a secondary mash tun that holds pressure), a gravity-fed lauter tun, a kettle and a whirlpool. He also has a cold liquor tank and a hot liquor tank. Note that when it comes to counting how many "vessels" are in your brew system, hot and/or cold liquor tanks are not counted. Don't ask me why, but they just aren't.

The benefit of a five- (or four-) vessel system is that the brewer can run a split process and do approximately three brews in a workday, whereas a two-vessel system could only do one brew in that same amount of time.

The semiautomatic part of his brew system involves programming and pneumatic butterfly controls that can be run through a touch screen such as an iPhone or an iPad. Those of you who enjoy talking brewing would do well to have a pint with Tomas and talk with him more about his system. He loves brewing, and he enjoys visiting with brewers and those who love brewing.

The Name

Tomas and his lovely wife, April, kept trying to come with a name for the brewery that would both reflect who they are and pass trademark. Many of the names they wanted to use were already taken. One day, while working on this problem, Tomas asked what name would reflect the culmination of all they had done and loved. A light bulb went off, and Culmination Brewing Co. was born.

The Beer

Tomas will be making a number of beers at Culmination including at least four seasonal IPAs: an imperial black IPA, a strong IPA, a session IPA and a Belgian-style IPA. Speaking of the black IPA, Tomas grew up in the Midwest, where according to him, black IPAs are common. In the Northwest, we have Cascadian Dark Ales (CDAs). Some Northwest beer writers suggest that there is no difference between a black IPA and a CDA. Tomas intends to have both a black IPA and a CDA on tap at the same time. That should make for some interesting discussions.

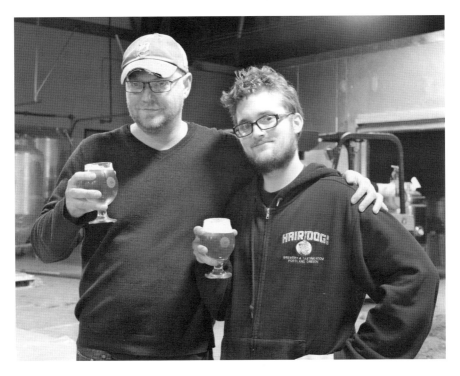

Culmination founder Tomas Sluiter and executive chef Carter B. Owen.

The Food

Carter B. Owen is the executive chef at the Culmination Kitchen. Carter grew up in Burlington, Vermont. In 2013, he moved to Portland, determined to make his mark in the culinary world here. He wanted to either become an executive chef somewhere or open a food cart.

Carter owns a catering company, Vermont BBQ, and has designed a menu for the Culmination Kitchen that reflects his loves of both pork and BBQ. When someone tells Carter that there is no such thing as Vermont BBQ, he smiles and says, "There is now."

The Music

Tomas was a musician all though high school, and he is a huge music fan. He is installing a high-end recording studio at Culmination for local musicians, and he will be having live music in the taproom and a monthly concert in

the brewery itself. People will sit in the actual brewery, next to shiny tanks, to hear a live concert preformed by local musicians. During these concerts, the private bar at very back of the brewery will be open to those attending the concert.

When I interviewed Tomas, he told me that he felt that brewing was the intersection of art and science. I think that the same thing can be said about Culmination Brewing.

• DOOMSDAY BREWING CO. •

The End Is Near, Drink a Beer

Erik Cloe and Jake Walton met at the beginning of fifth grade in Mr. LeCount's class at Captain Strong Elementary in Battleground, Washington. Their friendship began two months later when they attended a Halloween party. It seems fitting to me that the founders of Doomsday Brewing became friends at a Halloween party.

Erik Cloe and Jake Walton, founders of Doomsday Brewing.

Ten Portland Brewer Stories

Brewing in a Turkey Fryer

Erik and Jake began homebrewing in 2005 while they were in high school. Their first system consisted of a five-gallon turkey fryer with a propane flame. A red cooler served as the mash tun, and they fermented in a five-gallon bucket. They were told by friends (who were over twenty-one) that their first batch was not that great. Over the years, though, they have become fantastic brewers. In 2014, their beet beer, known as Beatdown Beet Wheat, won the People's Choice award at the Portland Spring Beer and Wine Fest.

In 2012, Erik and Jake decided to take their brewing seriously and began homebrewing every weekend in Jake's garage on a three-barrel system. They had seen the growth of the craft beer business, and they wanted to open their own brewery. This began more than two years of working seven days a week and putting in fourteen to sixteen hours on many days. They would put in eight hours at their day jobs working for a local disaster restoration and carpet cleaning company and then come home and work on their "brewery." Finally, in July 2014, they both quit their day jobs and became full-time brewers when they moved to their current location, which has a seven-barrel system.

"Apocalyptic" Is Too Hard to Spell

In 2012, when they began their brewery journey, they joked about the world coming to an end due the Mayan calendar controversy. They wanted to name their brewery "Apocalyptic," but they discovered that, for them, that word was too hard to spell. Thus Doomsday Brewing was born.

Jake and Erik launched Doomsday with their Nuclear IPA, Redemption Red and Ender Vanilla Porter. They have since added a number of great beers to their lineup, including the aforementioned Beatdown Beet Wheat, the Black Out Chocolate Stout and the Solar Flare Citrus Wheat, to name just a few.

Beer Dreams Do Come True

Jake and Erik love brewing, and their enthusiasm is very evident. They get a kick out of serving beer in their taproom to people who don't know that they are the brewers and hearing those people talk about how much they enjoy

the beer. In 2012, they set out to open a brewery, and now they have the joy of seeing their beer on the shelf at their local Fred Meyer and seeing their taps in local bars. Erik and Jake are proof that beer dreams do come true.

Across the River

I am very aware that Doomsday is across the river in Washington State. You drive north out of Portland across the I-5 bridge or the 205 bridge, and even though you have only crossed a river, you are in a different place all together. I myself have lived in both Portland and Vancouver, and they have very different cultures. It is common for people living in one of those two places to have NO interest in crossing the river to visit the other.

Truth be told, a lot of good beer is being made across the river in the Vancouver area. Breweries such as Amnesia, Dirty Hands, Loowit, Heathen and, yes, Doomsday make taking a day trip across the river to drink beer a great idea.

My friend and celebrated brewer Bolt Minister is in the process of opening the 54° 40' Brewing Co. in the Vancouver area, and when Bolt's brewery opens, you can bet that many Portland area beer fans will make a pilgrimage north to enjoy his beer. Hopefully they will make an additional stop or two before they head back across the river.

· ECLIPTIC BREWING ·

"This is Your Job. Go Get It!"

When people who know the Portland beer scene heard that I was writing this book, I would consistently be told that I *had* to include two Portland brewers. John Harris was one of those two brewers. John is a truly legendary Oregon brewer, and I am thrilled that I was able to include his story.

In the mid-'80s, John found German-imported beer and loved the flavor. Around the same time, the Portland beer scene was just getting going. John would try new beers as they came out, and he soon started homebrewing. John had found Fred Eckhardt's book *A Treatise on Lager Beers*, and that was the book he followed while homebrewing.

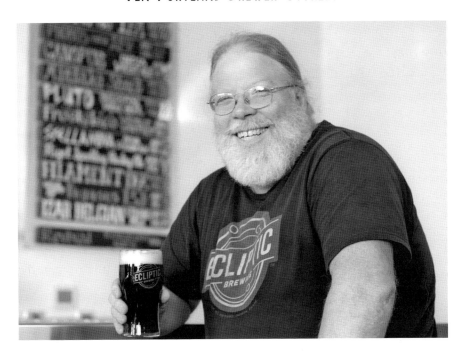

John Harris from Ecliptic Brewing.

In 1986, John's friend Lori handed John a copy of the *Willamette Week* and showed him a job posting that read, "Brewer needed at the Hillsdale Brewpub." Lori knew of John's growing love for beer, and she emphatically told him, "This is your job. Go get it!"

John was not sure that he could get a job as a brewer, but Lori insisted that he apply. John did apply, and he was hired. He brewed for McMenamins at both Hillsdale Brewpub and at Cornelius Pass Roadhouse for two years before moving on.

The Very First Brewer in Bend, Oregon—Ever!

John ended up being hired to be the founding brewmaster at Deschutes Brewing. Not only does John have the distinction of being the founding brewer of Deschutes, but he is also the first brewer that Bend ever had. I really think that the City of Bend should erect a statute of John. John stayed at Deschutes for four years, and then he moved on to be the founding brewmaster at the Full Sail Brewery at Riverplace in Portland.

Portland Beer Stories

Time to Pursue a Long-Held Dream

For more than twenty years, John thought about opening his own brewery. In the fall of 2011, he began to seriously consider taking that step, and in the spring of 2012, he decided that he would go for it. John left Full Sail and began the journey of starting his own brewery.

One of the biggest challenges was finding a building. John looked at scores of possible locations and ended up making offers on seven different buildings. The seventh one was the winner.

The Name

The name for John's brewery originated when he attended Five Oaks Middle School. An uncle had given him a telescope, and for a couple years, John spent many enjoyable hours looking into the night sky. But by the time high school rolled around, John had moved on to other hobbies.

In 2002 while traveling for Full Sail, John was in an airport looking for a magazine to read on the airplane, and he came across a copy of *Sky and Telescope*, a magazine about astronomy. While reading it on the flight, it brought back many good memories, and he subsequently got back into astronomy.

The ecliptic plane is the imaginary plane that the planets follow as they travel around the sun. The earth's travels around the sun give us our seasons, and at Ecliptic, the focus is on both seasonal beer and seasonal food. Each of the beers at Ecliptic has an astronomical name, some including stars, moons around Mars and constellations.

Amazing Food

When John opened Ecliptic, he was committed to having a restaurant that served very good food. John believes that excellent beer deserves excellent food. I have to say the food at Ecliptic is top notch. Ecliptic is one of the breweries featured in *Portland Beer Stories* at which I highly recommend you enjoy both a beer and a meal.

It warms my heart to see John brewing beer at his brewery. A dream he held for more than twenty years has come true. John really is living the dream.

Van Havig and Ben Love from Gigantic Brewing.

· GIGANTIC BREWING COMPANY ·

"We Are Oregon Brewers! Come On!"

In 2012, Ben Love and Van Havig opened Gigantic Brewing, and they have built a huge following of people who are very passionate about their beer. Ben and Van got to know each other while they were serving on the board of the Oregon Brewer's Guild. One fateful day, they were working on the Oregon Brewer's Guild Cheers to Belgian Beers event and looking for a space to hold that event. At the end of that day, they were at Belmont Station having a beer. Ben held up his hand, pointed at both Van and himself, and said, "Let's do this. Let's open a brewery."

The Name Is Ironic, and It's Not

As they began to talk about what kind of brewery that wanted to build, Ben asked Van "What do we want this brewery to be? What's the plan?" Van answered, "I don't what this to be some f***in' gigantic brewery."

They both smiled, knowing that they had just come up with the name for their brewery.

Listening to their story, I got the sense that the reason they did not want to be "some f***in' gigantic brewery" had to do with neither of them wanting their brewery to become a large corporation with an unhealthy, life-killing culture. I have worked at companies like that, the kind were you end up feeling like you need to work hard to keep the company from screwing over the clients and where the employees joke about how bad things are as a way to survive the day-to-day grind.

Gigantic is not like that at all. In fact, it is very fulfilling to Van and Ben that they have a team of people working with them who want to be at Gigantic. My hat is off to their having stayed true to their hopes and dreams and built a company with a healthy culture. It's not easy to do.

Both Ben and Van give credit to the places where they worked before opening Gigantic. Those experiences helped them learn what kind of corporate culture they wanted to have. Ben learned a number of very helpful things working at both Pelican and Hopworks. As far as Van's experiences before Gigantic, let's just say he learned much from the some of the places he worked at as well. Sometimes learning what *not* to do can be as instructive as learning what to do.

Gigantic is not an ironic name because from before they even opened their doors, they wanted to do some big things. They wanted to be distributed in a number of cities and even in Japan. They wanted Gigantic to be bigger than the beer world; they wanted to be able to take their beer beyond just the craft beer fan.

Today, you buy Gigantic beer in places like Oregon, California, Washington, Colorado, Alaska, Chicago, Canada, Europe and, yes, even Japan. Hatos Bar is in the Meguro neighborhood of Tokyo, and it serves "real pit BBQ and craft beer." Its beer list includes craft beer giants such as Stone, Green Flash, Three Floyds and Gigantic.

Ben and Van have partnered with artists on each of their bottle labels. Each label is also available as a poster. You can check out each of their labels on the Gigantic website.

The Beer

At Gigantic, you almost always get the Gigantic IPA Beer #1, the Ginormous Imperial IPA Beer #88 and Pipe Wrench Beer #24 aged in Ransom Old

Tom Gin barrels for three months. The rest of the beers they have on tap now will likely not ever be made again. That's how they roll.

People still ask they about two beers they made early on, Axes of Evil Beer #3 and Most Premium Russian Imperial Stout Beer #15. If you find a seasonal that you like at Gigantic, made sure you that enjoy while you can. Once it's gone, it's gone.

When I asked Ben and Van why IPA, they smiled and said, "We are Oregon brewers! Come on!" They love IPA, and from the very start of Gigantic Brewing, they wanted to make "the best damn IPA in Portland." Many of their fans will tell you that they have hit that gigantic goal.

• GROUND BREAKER BREWING •

People Come in Here and Cry Tears of Joy

Ground Breaker Brewing is the first gluten-free brewery in United States. Not only does it make gluten-free beer, but both the brewery and the gastropub are also certified gluten-free. If you have celiac disease and are

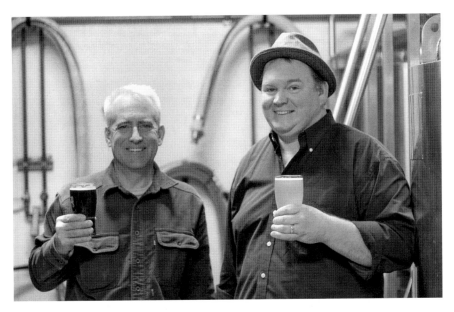

Tim Barr, brewmaster, and James Neumeister, founder of Ground Breaker Brewing.

gluten intolerant, Ground Breaker is a cherished treasure you thought you might never find.

James Neumeister grew up in Brownsmead, Oregon, a small community that is northeast of Astoria. People who hear about Brownsmead sometimes say that there isn't anywhere in Oregon that is northeast of Astoria, expect maybe the Columbia River. Those people are mistaken.

James spent years working in manufacturing as a machinist. One day he decided to make a complete career change and thought that culinary school would be a good start. James attended Western Culinary Institute in Portland. While in culinary school, he found homebrewing and realized that beer and not cooking would be his destiny.

James went to FH Steinbart, bought supplies and started homebrewing is his garage. He joined the Oregon Brew Crew, and he won the Widmer Collaborator homebrewing competition in 2010. Winning the Widmer Collaborator is a big deal. When you win this competition, Widmer brews your beer and you get to enjoy seeing your beer on tap at local Portland pubs.

On a Mission

In late 2008, a friend of James was diagnosed with celiac disease. If you are a celiac, you can't have gluten, and that means that most beer is off the table. James discovered that the gluten-free beer that was available for his friend to drink was, to quote him, "awful." James now had a mission. He went into his garage determined to figure out how to brew great-tasting gluten-free craft beer.

In December 2011, James opened Ground Breaker Brewery, the country's first gluten-free brewery. As James was installing his brewery, he consulted with Tim Barr, a brewer with whom Teri Fahrendorf had suggested James work. By March 2012, Tim joined the Ground Breaker team and became the brewmaster.

I Know What You Are Thinking

In 1987, Tim Barr was a quality control specialist for Pepsi in Eugene, Oregon. Tim and his girlfriend (who later became his wife) took a weeklong vacation to Victoria, British Columbia, where they came across Spinnakers Brewpub. Every afternoon of their vacation, Tim and his girlfriend would have a beer at

Spinnakers. Toward the end of the week, they had gotten to know the staff a little, and the brewer offered to give them a tour of the brewery.

Tim began to see that some of the equipment looked like the equipment he used to make soda. Tim asked the brewer, "How did you become a brewer?" The brewer looked up, smiled and said, "I know what you are thinking. You can do this. I was a line cook before I was a brewer."

Tim went home and started homebrewing, and he got to know a number of the brewers in Eugene, including Teri Fahrendorf. Teri suggested that Tim attend Seibel and become a brewer. Tim paid his own way to Seibel and headed off to Chicago. When returned to Eugene, he got his first job as a brewer working at West Brothers Eugene City Brewing.

Tim then got recruited to brew in Utah. He worked at two different breweries and stayed in Utah for a number of years before returning to Portland, where, a few years later, Teri Fahrendorf connected him to James Neumeister, who needed some advice about the brewery he was installing.

The Beer

Beer is commonly made with barley, which has gluten. If you are going to make gluten-free beer, you need to find something else with which to make beer. James hit upon the idea of brewing beer with lentils and later chestnuts. The lentils are roasted at different degrees and for different lengths of time depending on the flavors and colors desired in the beer. It still blows my mind that Ground Breaker makes beer—really good beer—out of lentils.

There are eight taps in the Ground Breaker Gastropub, with four year-round beers: a pale, a dark and two different IPAs. They also have a number of seasonal beers and one-offs on tap. It is one thing to be a celiac and find one good gluten-free beer. It is quite another to walk into a pub and find eight different great-tasting gluten-free craft beers on tap.

The Food

While in culinary school, James met Neil Davidson, and they became friends. Unlike James, Neil loved culinary school, and his career took him to California, where he worked at places like the French Laundry.

In the summer of 2013, when James decided to open up the Ground Breaker Gastropub, he knew exactly who he wanted to be his executive

chef. Neil agreed, and in October 2013, the Ground Breaker Gastropub opened. The food is wonderful and gluten-free, a combination that you don't always see. The menu is seasonal and includes local, fresh ingredients. Go to Ground Breaker, have dinner and thank me later. Make sure that you leave room for dessert. The desserts are exquisite.

A not uncommon occurrence at Ground Breaker is for people to come in for the first time and cry tears of joy. As Ground Breaker fans Tim and Christy told me, "Being able to drink not just one beer but eight beers to choose from and have an amazing meal, it makes us feel normal." Christy was diagnosed with celiac disease a number of years ago, and the thing she missed most was craft beer. Christy put it this way, "As a craft beer fan, I could only drink so much wine before I would want a beer." Thanks to Ground Breaker, she can once again enjoy a great-tasting craft beer whenever she wants to.

Whether gluten-free matters to you or not, Ground Breaker is a Portland beer destination not to be missed.

Beer Writer's Perspective
Pete Dunlop

Pete Dunlop is the author of Portland Beer: Crafting the Road to Beervana *(2013) and has written for* BeerAdvocate, Willamette Week *and others. He has been observing and enjoying Portland's beer scene since arriving in 1989, and he started writing about it in 2011, when he founded the blog beervanabuzz.com. Prior to beer, Pete earned a master's degree in history at Washington State University and spent more than fifteen years working in corporate marketing communications and journalism.*

The question of how and why Portland came to be recognized as one of the most prolific beer cities in the world is not exactly an open book. Portland is what it is for many reasons. Honestly, the city's status has little to do with the fact that it is home to more breweries than any other city in the world. The actual brewery count surpassed fifty and then sixty in recent years and seems destined to grow further. But the number is largely irrelevant because breweries alone don't tell the full story. There's much more at work here.

It's significant to note that the craft beer revolution launched here in the 1980s did not originate in Portland. Indeed, the roots of the movement on the West Coast can be more accurately traced to the San Francisco Bay area and Seattle, which had existing craft breweries before Portland jumped on the bandwagon. However, once Portland got in the game, the number of breweries grew quickly and the industry flourished. There was something about Portland that made craft beer a perfect fit.

Over the years, many theories have been suggested. It was the water; it was the proximity to fresh hops and grains; it was the strong pub culture dating to the nineteenth century, encouraged by foul weather that forces citizens inside for much of the year. These are all fine explanations and likely played a role in what occurred here. In fact, many American cities have access to good water and ingredients. Lots of places have dreadful weather that forces residents to seek refuge in pubs and public houses. Portland has all of these things, for sure, but it is not alone.

One of the first things that is decidedly different here is a strong sense of provincialism and do-it-yourself culture. The relatively small size of the city, compared to its neighbors to the south and north, may well account for these influences, which date to the nineteenth century. Homebrewing was popular in Portland long before it was legalized nationally during

the Jimmy Carter presidency. A big reason the founders of craft brewing flourished is the strong sense of provincialism that encouraged people to try things that were local and different. Folks who were quite happy with the macro swill they were drinking were nonetheless pleased to try craft beer. And it caught on.

The shadow of Blitz-Weinhard also looms large in this conversation. It was the lofty stature of the old brewery that provided Portland with a strong link to local beer and pubs. The 1976 release of Henry Weinhard's Private Reserve, a premium product targeting discriminating beer fans, effectively predicted the coming of craft beer a decade later. Obviously, other cities had influential breweries dating to the nineteenth century. But Weinhard was a large, regional brewery situated in a small city, which magnified its influence on consumers, brewers and entrepreneurs to be. The early craft brewers visited Blitz-Weinhard often and received input and advice. Even as the old brewery staggered toward the end in the 1990s, it was held in high esteem by the community.

Perhaps most significant, craft beer became linked with a movement that transcended beer. That movement itself was underway by the 1960s and represented a paradigm shift away from the lighter, blander preferences of the prior generation. Instead of industrially processed, quickly prepared and very often flavorless foods and drinks, a growing number of Americans came to prefer foods and beverages that were full of flavor, local and handmade. Advanced culinary values were part of that shift, as was homebrewing in some circles, which led to commercial brewing. Small city, provincial Portland embraced these ideals, which help explain what happened and what continues to happen here.

Possibly the greatest thing about modern Portland as a beer city is the huge number of establishments that feature excellent beer. Even the dive bars have jumped on the craft bandwagon. What are the prime destinations? One is Hair of the Dog Brewing in Southeast Portland, where brewer Alan Sprints creates small batch and barrel-aged beers that are unsurpassed in originality and flavor. A short distance away, still in Southeast Portland, is the Horse Brass Pub, once owned by the late Don Younger. Younger was an early convert to craft beer and worked with the founding brewers to promote their wares. Today, the Horse Brass remains true to Younger's vision, consistently offering up one of the most expansive tap lists in the city. Finally, there's the Commons Brewery, also in Southeast Portland. Launched in the garage of owner/brewer Mike Wright before moving to a charming tasting room, the Commons has ridden an exquisite line of Belgian-influenced beers to great reviews and popularity.

SIX PORTLAND BEER STORIES

FROM BEER BUS TO BEER TRUCK DRIVER

• ASHLEY ROSE SALVITTI •

From Portland Beer Fan to Businesswoman

If you are a fan of Portland beer, the Brewvana tour is something that you should do. Let me put it to you this way: if you are only going to do one beer-related activity in Portland, go to the Hair of the Dog and have a beer and a meal. If you are going to do two beer-related activates in Portland, first go to the Hair of the Dog and have a beer and a meal and then go on a Brewvana tour. It really is that good.

From Greensboro to Portland

When Ashley Rose Salvitti was in seventh grade, her parents moved her from Fairport, New York, to Greensboro, North Carolina. Ashley is still not pleased that they did this. As she put it, "You should never move a seventh grader away from her friends." Of course, Ashley said that with a smile. It turns out that Greensboro was not that bad of a place after all.

When Ashley was in high school, her dad, John aka Papa Sal, was quite the beer fan. He loved trying new beers, and he always had a growler in the fridge from one of the local breweries. He became an accomplished homebrewer. When Ashley was in college, she got a job at the High Point, North Carolina

Ashley Rose Salvitti, founder of Brewvana Portland Brewery Tours.

Liberty Brewery & Grill, and her dad would always make a point to come see her and have a beer.

Ashley graduated from the University of North Carolina–Greensboro, and she was ready for a change of scenery. Ashley had a friend in Seattle, and she almost moved there. However, Ashley wanted to move to a city on her own to show herself that she could do it. Everyone that Ashley had ever met from Portland loved living there, so in 2007, she packed her bags and headed for the Rose City.

Ashley had been a server in North Carolina, and when she got to Portland, she started working at Laurelwood. A year later, she moved over to Hopworks. Ashley became a huge fan of both Portland and our breweries.

Every time someone from her family would come from North Carolina to visit, Ashley would show them around. She loved playing tour guide and showing them all the great things about her city. Ashley always made sure to include a couple breweries on her tour stops.

Brewvana Portland Brewery Tours: A Brilliant Idea

In 2009, Ashley got the idea that she was going to start a brewery tour business. She told this to Quinn, one of her regulars at Hopworks, and Quinn said, "That is a f***ing brilliant idea!" Ashley knew that she could give a great brewery tour in which her customers would get an insider's perspective and get to enjoy awesome beer.

On April 8, 2011, she gave her first tour, and now each year in April, Brewvana throws a big party to celebrate the anniversary. Today, Ashley owns three busses and offers both walking tours and bus tours. The tours are

both very informative and a lot of fun, as well as very well organized. One interesting fact: Brewvana even offers tours in Japanese.

If you live in Portland, you should really go on a Brewvana tour. You will have a blast, and you will learn things about the Portland beer community that you never knew. Brewvana really does offer an insider's tour.

I love it that Portland is the kind of place where a hardworking, determined young woman can take a passion for beer and breweries and turn it into a successful business. I am sure that Papa Sal is very proud of his daughter.

· BRIAN BUTENSCHOEN ·

One of the Best Job Titles in Portland

When people ask Brian Butenschoen what he does, he gets to slide over a business card that says "Executive Director of the Oregon Brewer's Guild" on it. How awesome is that! Brian has been the executive director since May 2005. Prior to that, Brian homebrewed for more than five years; he successfully completed the Beer Judge Certification Program; he joined the Oregon Brew Crew and has been its secretary, vice-president and president; and he has worked at Belmont Station. Brian loves craft beer, and he very much enjoys his role in making craft beer magic happen.

Oregon Brewer's Guild 101

The Oregon Brewer's Guild is a nonprofit organization that exists to serve the brewing industry here in Oregon. The Oregon Brewers Guild was founded in 1992, and it is one of the oldest craft brewers associations in the United States.

To become a member, you need to be licensed to brew beer in Oregon, and you need to be actually brewing beer here in Oregon. If you are a company that does business with breweries in Oregon, such as a malting company or an accountant or a law firm who specializes in Oregon breweries (we have those here), you can become an associate member of the Oregon Brewer's Guild.

If you are an Oregon beer enthusiast, you can support the Oregon Brewer's Guild by purchasing an annual membership in Supporters of

Native Oregon Beer (SNOB) for twenty dollars. With your membership, you get an official membership card, a Supporter of Native Oregon Beer t-shirt, an Oregon Brewers Guild sticker, a subscription to the SNOB e-mail newsletter and invitations to exclusive SNOB meet-ups.

Zwickelmania and More

The Oregon Brewers Guild sponsors a number of events each year, including the Oregon Craft Beer Month (that happens in July), Cheers to Belgian Beers (generally late spring) and the regional Fresh Hops Festival (September and October).

One of the Oregon Brewers Guild's most successful events is Zwickelmania. Zwickelmania happens every February and is a statewide brewery open house. On the day of Zwickelmania, every brewery that is part of the Oregon Brewers Guild opens its doors to the public from 11:00 a.m. to 4:00 p.m.

A zwickel. Zwickelmania gets its name from this nozzle.

Each year more than forty thousand people head out to get a behind-the-scenes glimpse of their favorite Oregon breweries. During Zwickelmania, breweries often give out free beer and sell special beers that they brew just for this event.

What Is a Zwickel?

Zwickel is German for "sample pour," and it is also the name of a nozzle that is added to a brite tank so that a brewer can easily check the taste of the beer in it. When Zwickelmania was started, the idea was that the public would be able to tour a brewery, and at the end of the tour, they would be able to get a sample pour right out of a brite tank via the zwickel. This event quickly became too popular to make that feasible, but the name stuck.

· BRUCE WOLF ·

He Grew Up on a Hop Farm

Hop farmers grow hops. Brewers need hops to brew beer. Hop distributors make the connection happen. When a hop distributor is doing his or her job, the farmer is freed up to tend to his harvest, knowing he has someone ready to buy his hops. The brewer is freed up to brew beer knowing he has someone who will get him the hops he needs. Here is the story of one local hop distributor.

Destined for the Hop Business

In 2009, Bruce Wolf started Willamette Valley Hops. Bruce literally grew up on a hop farm. Hop farming goes back on his mother's side for four generations and, on his father's side, five generations. Following school, Bruce got a "good" job outside of farming. He learned two things from that experience. First, he does not do well working for the man. Bruce does much better being self-employed. The second thing he learned is that when summer arrives, he is drawn back to the hop farm and would rather be there.

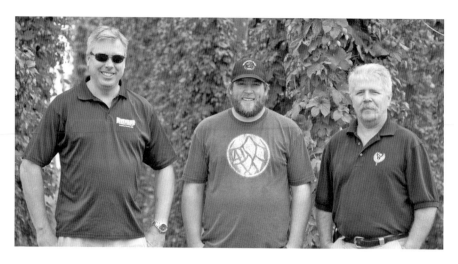

Bruce Wolf of Willamette Valley Hops (center) and Mark Noble and Buddy Everhart from Aviator Brewing Company.

In the summer of 2008, Bruce was helping two hop farmers, his grandfather on his mom's side of the family and his great-uncle on his dad's side of the family. It was that summer when Bruce realized that his entire life to that point had prepared him to start a business distributing hops. He already knew that his wiring was more conducive to self-employment than to being an employee. The decision was an easy one, so Bruce went for it, and he started his own business.

Today, Bruce has an impressive list of clients. He has to keep both hop farmers *and* brewers happy. It made sense to me why a hop farmer would want to do business with Bruce: he knows hops, and he knows hop farming. A number of the breweries in this book do business with Bruce. The question I had was, "Why?" I found that answer talking with Paul Michael Allard.

Michael Cares About His Brewers

Paul Michael Allard, who goes by Michael, is the East Coast representative for Willamette Valley Hops. Michael covers the states that touch the Atlantic Ocean from Maine to Florida, all of New England and the state of New York. Michael has the contacts with the brewers and could easily rep for some other hop distributor if he wanted to.

I can't give away any trade secrets, but I can say this: the way that Willamette Valley Hops does business equips Michael to partner with his

brewers. Michael does not want to sell a brewer hops this year. He wants to sell a brewer hops for the next ten years, and he takes great pride in helping "his" brewers.

Michael is so blasted sincere it almost hurts. If I were a brewer, I would buy definitely hops from Michael no matter who he repped for. Michael would have my back and look out for me and my company.

Once I understood why Michael wanted to rep for Willamette Valley Hops, I knew why brewers wanted to do business with Willamette Valley Hops. The company is in it for the long term and has its clients' backs. If you are a farmer or a brewer, the members of the Willamette Valley Hops team—Bruce Wolf, Derek Wolf and Paul Michael Allard—have your best interests at heart.

What Are Hops?

If you don't know, the answer will likely surprise you. Hops are flowers. Specifically, hops are the female flower of hop plant. Hop flowers are also called cones. Most of the world's hops come from Germany and the United States. In Germany, hops are mainly grown in the Hallertau, an area in Bavaria. In the United States, hops are mainly grown in the Yakima Valley in Washington and the Willamette Valley in Oregon.

The process of harvesting hops is pretty amazing. If you ever get the chance to go to a hop farm and/or a hop processing facility when the hop harvest is on, do it. In a nut shell, when the harvest is on, hops get cut down or trimmed and taken to a building where a machine known as a picker strips off the cones, leaves and stems. Then the cones, leaves and stems get sorted in another machine, and at the end of this machine, cones drop out. The cones (flowers) are then baked at about 150 degrees in a big huge oven. This step in the process smells amazing! The cones are baked to remove moisture so that the hops can be shipped and stored. The hops are then put into huge piles, where they cool for about twenty-four hours before they are pressed into two-hundred-pound burlap sacks. Once that happens, they are ready to be shipped and stored.

Thanks to our friends at Willamette Valley Hops, Ken Wilson and I were given access to film *all* of these steps during the 2014 hop harvest, and you can find that video on the Portland Beer Stories website, www. PortlandBeerStories.com.

· JOHN DEBENEDETTI ·

Serving Brewers and Homebrewers for More Than Forty Years

In 1975, John DeBenedetti bought FH Steinbart, the oldest homebrew supply store in the United States. Few people have influenced the Portland beer community more than John.

FH Steinbart Co. was founded here in Portland in 1918 by Frank H. Steinbart. Prohibition started two years later in 1920. FH Steinbart survived Prohibition because when beer became illegal to purchase, a number of people turned to homebrewing. People may have homebrewed quietly and illegally, but they did it. FH Steinbart carefully and creatively sold them the ingredients and tools to do so. In 1934, Angelo Curtello and Joseph DeBenedetti (John's father) purchased FH Steinbart and kept it going. (As a

John DeBenedetti, owner of FH Steinbart Co.

side note, most people I have encountered call FH Steinbart "Steinbart's," and in fact, I don't think that I have ever heard anyone refer to this business as FH Steinbart.)

John DeBenedetti bought FH Steinbart from his father in 1975 and has shepherded it though many changes in the beer business. One of the biggest changes came when homebrewing was legalized in 1979.

When prohibition ended in 1930, the federal legislation allowed for a person to make wine at home, but making beer at home was left out of this legislation. It was not until 1978 that President Carter signed H.R. 1337 and this oversight was corrected.

On February 1, 1979, if your state said that it was okay to brew beer at home, you were good to go. If you lived in Oregon and you wanted to homebrew, you could. If you lived in Mississippi or Alabama, however, you could not legally homebrew until 2013.

The Oregon Brew Crew, Established 1979

Once it was legal to home brew in Oregon, none other than Fred Eckhardt came up with the idea start a home brew club to support Portland homebrewers. Fred talked about this idea with his friends John DeBenedetti and Ann McCallum, and the three of them got the Oregon Brew Crew going. To this day, the Oregon Brew Crew still regularly meets at FH Steinbart.

Over the years, just about every prominent Portland brewer that you can think of has walked through the doors at FH Steinbart seeking a part, help with a problem or just advice from John or someone on his staff.

Today, FH Steinbart sells supplies for homebrewers, and it has a draft department that helps business get taps set up in their brewpub, bar or restaurant. Brewers still stop by on a regular basis.

John is very humble and shrugs off any suggestions that he has played a significant role in the development of the Portland beer scene, but let me tell you, John is a true Portland beer legend. If you are a fan of the Portland beer scene, you have many reasons to raise a glass to him.

· JOHN FOYSTON ·

The Best of the Portland Beer Storytellers

John Foyston, beer writer extraordinaire.

Portland is blessed to have many good writers covering the Portland beer scene, and John Foyston, who has been writing about beer for the *Oregonian* since 1995, stands at the head of that line.

In 1987, John had a motorcycle shop where he repaired Italian motorcycles. One of his clients who owned a Ducati also happened to be the editor of the *Oregonian A&E*. There was a need for someone to attend and review concerts. One thing led to another, and John Foyston found himself at a Night Ranger concert. John kept writing for the *Oregonian*, and in 1995, he became a full-time staff writer for the *Oregonian A&E*.

The Noble Pursuit of Making Great Beer

During an *A&E* staff meeting in 1995, John said that they needed to start writing about the culture of craft beer. The people in the room agreed with this timely and prescient idea. John was the only one who drank craft beer, however, and the task was assigned to him.

John is everything I want in a beer writer: he is kind and humble, and he is a fan of the craft beer movement. For years, he has made the beer scene accessible to the people of Portland. He has been there telling the story, introducing his city to the beers, brewers and events that have made the Portland beer scene so magical. As John put it, he has covered those who are engaged in the noble pursuit of making great beer.

The first thing a brewer needs: rubber boots.

I asked John what makes a great brewer, and he answered with a smile, "Rubber boots." He then went on to add that great brewers are able to blend the art and science of brewing with a bit of genius and a lot of culinary skill. John also shared that great brewers enjoy brewing, and they have a good palette and a good flavor memory. John has immense respect for those who brew beer.

Nothing Compares to Portland

Since becoming a beer writer, John has had the chance to travel to many places enjoying beer, across the United States, England, Ireland and even Paris—they have craft breweries there, and John has been to them. As John and I were visiting and talking about his beer travels and the wonderful beers that he has enjoyed, he got a faraway look in his eye and said, "You know, when it comes to beer, nothing compares to Portland."

What Makes for a Good Beer

John's beer philosophy is that you should find beer that *you* like and drink it. He is not too fond of those who are more worried about whether a beer hits a certain style than whether they like the beer in the glass. John learned from his stepfather, Mac Church, that what makes for a good beer is a beer that makes you say, "That beer tastes like another."

When I contacted John to interview him for *Portland Beer Stories*, he said that we should meet up at BeerMongers. It was delightful to have a pint with him there and listen to his beer stories. He is the kind of guy that you want to have a beer with, and that is exactly what I want in a beer writer. John is the best of the Portland beer storytellers.

· JOSH HUERTA ·

"Is Rob Widmer Messing With Me?"

Josh Huerta loves the Portland beer community, and he says that with Portland he hit the jackpot. Josh was born in San Diego, and when he was one year old, his family moved to Ensenada, Mexico. When John was twenty-one, his father passed away, and he moved back to San Diego because his mom was now living there. The challenge for Josh was that he did not speak English and he had to learn it.

Time for a New Chapter

In 2003, it was time for Josh to get out of San Diego and start another new chapter of his life. He had cousins living in Portland who said that he should come check it out, though one of them said that it might be a little cold for him here.

Josh made the mistake of visiting Portland in late May. It was not cold at all. Josh loved what he saw, and he never left. He got a job right away driving a van for a nursing home. Things were fine until January arrived. It was very cold by then, and it had been raining for months. Josh wondered if it would ever stop raining.

One bright spot in Josh's first year in Portland was discovering craft beer. When he moved to Portland, Josh began reading the *Oregonian*. Every Friday, John Foyston had a beer column that listed places to go, and every Friday, Josh

would open the paper to see where John was going to send him. Josh got to know many people in the Portland beer community this way.

Josh eventually started homebrewing, and he joined the Oregon Brew Crew. He has since won more than forty medals in homebrew competitions. In 2011, Josh won the Widmer Collaborator. The Widmer Collaborator is a homebrew competition open to the members of the Oregon Brew Crew. The winner has his or her beer brewed by Widmer.

Josh remembers when he found out that his beer—the Pineapple Express, a pineapple Weizen ale—had won the Collaborator. Rob Widmer came up and told him, "Your beer won! I am excited that we are going to be brewing it." Josh could not believe his ears. He could not get his mind around the fact that he had won the Widmer Collaborator. He began to wonder if Rob Widmer was messing with him.

But Rob was not messing with Josh, and Widmer brewed seventeen barrels of Josh's beer. Josh even got to see his beer served at the 2012 Oregon Brewer's Festival.

In 2012, Josh's friend Jaime Rodriguez called him up and said, "Do you want to work for a beer company?" Josh said, "Are you kidding? Of course I do!" Jaime went on to tell Josh that Point Blank Distributing had an opening for a beer truck driver. Josh interviewed the very next day. When he got the job, he was overjoyed. He was now part of the beer industry. To this day, Josh loves his job delivering beer to his clients. As Josh put it, "Everyone loves to see the beer man coming."

Josh says that for him, moving to Portland was hitting the jackpot. He found his wife here, he found craft beer here and he gets to work in an industry that he loves.

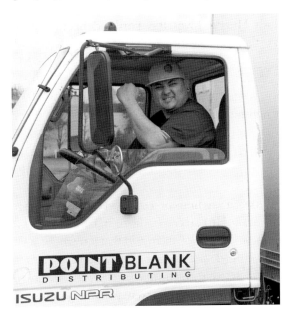

Josh Huerta, beer truck driver.

Beer Writer's Perspective
Ezra Johnson-Greenough

Ezra is the creator of the New School Beer website and founder of Portland Beer Week.

You can call it "craft," "micro," "nano," "artisan" or just plain "beer," but whatever it is, Oregon has been doing it better and doing more of it than any other place in the world. While Oregon's brewing roots date back to 1852 when Henry Saxer built the Liberty Brewery and continued on with the great Henry Weinhard, these guys were the grandparents of Oregon brewers. You could say the modern "craft brewing" era began with Oregon's oldest breweries still in operation—Bridgeport Brewery and Widmer Brothers Brewing, which made ales instead of the American Industrial Lagers of the first generation. At thirty years old, Bridgeport and Widmer make up our parently second generation of great brewers. The youngest generation started in the early 2010s and have ushered in an unprecedented level of growth and explosion of new breweries all over the country. It has become a prosperous time, with breweries doubling in size within a couple years, larger tanks and brewhouses and brewpub chains popping up everywhere. Craft brewers have been opening up huge production breweries on the other side of the country and even in other countries. I wonder if ten years from now they might look back on this period as a time of excess and over-confidence. Because along with all the tremendous success stories has came an onslaught of controversial lawsuits, in-fighting and sell-outs.

It's like our little industry is graduating from college and slowly entering the adult world, kicking and screaming all the way. Suddenly beer is becoming big business, and instead of just making beer they enjoy, brewers in the industry now must begin considering competition, branding, trademarks, distributors and becoming an increasingly large target for the international macro brewers. For those reasons, I believe the current brewing landscape will fight many of the battles that will pave the way for perhaps an even more prosperous generation. We are still stuck in a time when many state laws have not caught up with modern times, where wine enjoys less restrictions and beer distributors call the shots while unbalanced taxes limit growth. As a brewer, you must now think long and hard before you name your brewery or beer and, even more wisely, have a lawyer vet that name to protect against future legal situations arising from trademarked names. Be careful of getting too big because then you may need a beer distributor, and once you sign

a contract with one of them, good luck getting out of it without paying millions of dollars. If you're going to package your beer and try to sell it in grocery stores, you must decide between bottles and cans; once you do that, you have to decide between six-packs, four-packs, tall boys or bombers, and that choice will mean hundreds of thousands of dollars up front, not to mention determining what stores will carry your beers.

For all of these conflicts that seem to come up on a weekly basis, Oregon brewers are cutting a trail for the rest of the nation to follow. More and more community colleges and universities are starting brewing programs that go beyond how to simply make beer. At Oregon State University in Corvallis, you can study fermentation science but also learn about hop breeding and cultivation from renowned professor Tom Shellhammer. In the Salem area, we have hop farmers by the names of Leavy and Goschie who are pioneering the farming of organic and salmon safe hops. In Newport, Rogue Brewing is now malting its own grains. In Portland, you can study the "Business of Craft Beer" at Portland State University and learn how to open and market a new brewery. In Hood River, the Wyeast Laboratory has made a name for itself as a leader in growing yeast cultures for home- and pro brewers alike. Hell, in Oregon we even have law firms, industry networking groups and real estate brokers who specialize in working with small brewers. In a state that already has one of the most established industry and lobbying organizations, the Oregon Brewers Guild, there are more sub-guilds and groups like the Central Oregon Brewers Guild, formed in 2012, and the brand-new Breweries in the Gorge, formed in 2015, that brings together brewers from the Oregon and Washington side of the Columbia River. Nonprofit industry professional groups like these are essential resources for small and new brewers to navigate the hurdles of the industry while protecting and lobbying for their members. These are incredible assets that small brewers did not have twenty-five years ago and may still not have in other places of the country. Perhaps that's part of what has spurred the success of the new trend in nanobreweries popping up on one- to three-and-a-half-barrel breweries from homebrewers' garages with relatively little funds needed to start up. The more successful among these could become the next Bridgeport Brewing or Widmer.

Sure, the large multi-national corporations may continue to pick off the uber-successful regional breweries, but a bigger picture is emerging. In a world where breweries are as plentiful as coffee shops, Starbucks may have thousands of stores, but there is plenty of room for mom-and-pop operations. Oregon, ahead of the rest of the country, may be the first

state where you can look forward to finding a small local brewpub in every neighborhood and every small town. Think there is not enough room for all these startups? Does the local diner with that fantastic burger made of grass-fed hamburger from Carlton, cheese from Tillamook and a bun from Portland have anything to worry about from a Burger King product sourced from an impoverished country?

ROAD TRIP!

· ASTORIA ·

Fort George Brewery

Chris Nemlowill and Jack Harris opened Fort George Brewery in March 2007, and they have been on a rocket of growth ever since. This is how that rocket got started.

Chris Nemlowill and Jack Harris from Fort George Brewery.

Portland Beer Stories

Jack Harris: A Career Brewer

Jack Harris finished college and went to work at the McMenamins Raleigh Hills Pub in Portland. Jack started out as a server and then moved into the kitchen. A year later, he was given the chance to move to the McMenamins Cornelius Roadhouse and become a brewer. Jack took the opportunity and made the most of it.

From there, Jack moved to the McMenamins Lighthouse Brewpub in Lincoln City. Jack loved living on the Oregon coast. Jack then went to Boulder, Colorado, and was the founding brewmaster at Mountain Sun Pub & Brewery. That was followed by a stint at Cascades Lakes Brewing Co. in Redmond, Oregon.

Remember how I said that Jack loved living on the Oregon coast? Well, his next move took him back there. He began brewing at Bill's Tavern and Brewhouse in Cannon Beach, Oregon, where he stayed for nine years. It was then that Chris Nemlowill walked into his life.

"If I Could Have Any Career I Wanted..."

In 2003, Chris Nemlowill was going to graduate from Southern Oregon University in Ashland and head to a major corporation to become the proud owner of a small cubicle of his very own. The day before graduation, he discovered that he just couldn't do that. That kind of career would kill him a little bit every day for forty miserable years.

When he thought about it the night before graduation, he realized that he wanted to work in the beer business and, if possible, start a brewery. He decided that he was going to do pursue that path. If Chris could have any career he wanted, he would have a career in craft beer, and he set out after it.

Was Chris a homebrewer at that point in his life? Nope. The closest he had been to brewing was enjoying beer at Caldera, an excellent brewpub in Ashland.

The day after graduation, Chris called his mom and said, "Mom, I want to come home, live in the basement and brew beer." Fort George fans everywhere are forever in his mom's debt for agreeing to this audacious plan.

Chris then bought six books on brewing at Borders Books and began his journey. Chris went home to Astoria, got a job as a barista and began homebrewing, something he did all summer. Chris heard that Jack Harris was a great brewer who lived in Astoria and worked at Bill's Tavern in Cannon Beach.

Chris formulated a plan and took some of his home brew to share with Jack. Chris walked into Bill's Tavern carrying his growlers, and he asked for Bill. The bartender told him to go back into the brewery. Chris did just that, and he met Jack Harris, his future business partner, for the first time ever. Chris shared his beer with Jack and asked for a 120-hour internship in which he would work for Jack for free for three weeks.

Chris ended up getting this internship, and then he got a job working for Jack. Chris was there a year before taking a brewing job at Astoria Brewing Co.

One day, Chris called Jack and said, "I've quit my job at Astoria Brewing. It's time." In October 2005, they looked at the space that Fort George Brewery sits on now. In the spring of 2006, they began to set that location up as a brewery.

They opened Fort George Brewery in March 2007, not quite four years after Chris had moved into his mom's basement with big hope and dreams. Somebody play the *Rocky* music.

When You Go to Fort George and Astoria

Make sure that you go to Fort George's Lovell taproom and check out the beer selection there. You will so want to have breakfast at the Columbia Café (get the lace potatoes and thank me later), go to the Bowpicker for lunch (it's a land-based food boat, kind of like a Portland food cart) and have a pastry or two at the Blue Scorcher Bakery Café. For dinner, eat at the Fort George Public House. The Anaheim pepper burger is amazing, and you cant go wrong with any of the house-made sausages.

One interesting fact: Fort George Brewery sits on the site of the first American settlement on the West Coast.

· BEND ·

Ale Apothecary

So much good beer is brewed in Bend! How could I pick just one brewer to write about? Who should I pick? Every time I asked one of my Portland beer writer friends about which *one* brewer from Bend I should write

Paul Arney of Ale Apothecary.

about, they each told me that Paul Arney was making the best beer in Bend. I am so glad that I listened. Paul makes incredible beer, and he has a very interesting story.

From Homebrewing in Everett, Washington, to Deschutes Brewery in Bend, Oregon

Paul's beer journey started when he was eighteen years old in his hometown of Everett, Washington, and his dad received a homebrewing kit as a gift. They brewed beer together a handful of times before Paul went off to Western Washington University in Bellingham, Washington.

Paul graduated with a degree in geology, and he subsequently realized that most of the job options that came with a degree in geology were not a good fit for him. He went back to Everett and got a job at Starbucks and began to figure out what to do with the rest of his life.

Tom Munoz was a brewer at Glacier Peak Brewing in Everett, and he began coming into that Starbucks where Paul worked. They became friends,

and Paul started helping out at the brewery. Through Tom, Paul learned that you could go to school and become a brewer. Paul enrolled in the Master Brewer Program at UC–Davis in 1995.

When he came close to finishing this program, Paul began to look for a job as a brewer. Paul sent over one hundred letters to each of the Oregon, Washington and Idaho breweries that were listed in the *Celebrator* beer magazine. He got two responses. The one from the Roslyn Brewing Co. in Roslyn, Washington, said that it was not currently hiring. The response from Deschutes Brewery said that it had a job waiting for him in Bend once he completed his schooling.

Paul loved Bend! The Nordic skiing, the hiking, the biking, the people and the three hundred days of sunshine were a perfect fit for him. Paul remained at Deschutes until 2011, when he left and began to build Ale Apothecary.

The Name

Paul is a true artisan in every sense of the word. He wanted to have a name for his brewery that did not include the words "brewing" or "brewing company" to make it clear that he was doing something different. The name Ale Apothecary is an homage to the three generations of independent drugstore operators in his family.

Interestingly enough, you will *not* find the name of Paul's brewery on his bottles. He could not get a label approved with the words "Ale Apothecary" on it because there was concern that someone

Ale Apothecary's Sahati label.

would think that his beer is medicine. A ludicrous concern, I know. So part of the Ale Apothecary mystique is that its bottles have the word "Apoth" on them.

Truly Hand-Crafted Artisan Beer

Paul makes his beer in a five-hundred-square-foot brew house in the forest outside of Bend. Talking with Paul, he sounded as much like a winemaker as he did a brewer. He talks about the beer having "local character," and he brews "batch vintages." Sahati brewed this year might be slightly different than Sahati brewed last year because of how "nature impacts that flavor of the beer."

Speaking of Sahati, this beer was inspired by the Finnish beer known as sahti. Some say that sahti is the oldest continuously made fermented beverage. Paul literally makes his Sahati in a hollowed-out spruce tree, and he uses spruce branches as a filter and to impart oils and flavor. Paul loves it that he can "take the process and turn it into one of the ingredients."

Paul sells his beer in 750-milliliter champagne bottles. I mean that is the ONLY way that he sells his beer. No twelve-ounce bottles, no kegs. Just 750-milliliter bottles. Each bottle has a cork, and the cork is tied down with a string. As you can already likely tell, when is comes to brewing, history matters to Paul. As he puts it, "Prior to the industrial revolution, all corked items were secured with a string."

Even the knot on the neck of the bottle is special. When Paul was first opening Ale Apothecary, he was searching online for a special knot to use on his bottles, and he came across the International Guild of Knot Tyers. Honest, that is a real thing.

One of its members directed Paul to a book written in 1849 by Friedrich Mohr and Theophilus Redwood called *Practical Pharmacy*. On page 300 in "The Tying of Knots" section of this book, you will find the very champagne knot that Paul uses on the neck of his bottles today.

The Beer

Paul's beer is some of best beer I have ever tasted. It is also some of the most different beer that I have ever tasted. When you visit Bend, make sure to stop by the Ale Apothecary tasting room. In Portland, you can sometimes

find Paul's beer for sale at places like the Belmont Station, the BeerMongers and Saraveza.

Bend is wonderful place to take a weekend road trip. It is home to many great breweries, as well as excellent distilleries and restaurants. One excellent book about Bend and beer is *Bend Beer* written by my friend Jon Abernathy.

· HOOD RIVER ·

Pfriem Family Brewers

Josh Pfriem grew up in the Green Lake neighborhood of Seattle. Following high school, he went to Western Washington University in Bellingham for business and marketing. It was in Bellingham that Josh came across Boundary Bay Brewery and fell in love with craft beer and started homebrewing.

When Josh's college classmates would say that they wanted to someday be the CEO of a Fortune 500 company or say that they wanted to start a tech company, Josh would say that he was going to become a brewmaster and open his own brewery.

Following college, Josh was "ski bummin'" in Utah, and while there, he got his first job at Utah Brewers Cooperative, which brews beer for two Utah-based craft beer companies, Wasatch and Squatters. While in Utah, Josh began a long-term pattern of brewing during the day for his employer and brewing at home at night to prepare himself for the brewery that he was going to be opening someday.

It was not uncommon for Josh to get up at 6:00 a.m., head to work, put in a full day and then come home and "fire up the kettle" and homebrew until midnight

Josh Pfriem, founder of Pfriem Family Brewers.

before heading to bed and doing it all over again the next day. Josh was in the hunt for his dream, and he was paying the price to make it happen. He was determined to learn all that he needed to so that when he did open his brewery, it would succeed.

Josh then moved back to Bellingham and became the founding brewmaster at Chuckanut Brewery. From there, Josh took a job in Hood River at Full Sail. It was that move that brought Josh and his wife, Annie, "home." Hood River fit them like a glove.

For Josh and Annie, Hood River was the perfect mountain town. It had biking, skiing and hiking. It was a great place to raise kids, as it had lots of families, and they found the people who lived there to be "passionate about life." They loved the fact that Hood River is surrounded by beautiful mountains and is only an hour from Portland. They knew that this was the place to set down roots and eventually open their brewery.

In August 2012, Pfriem Family Brewers opened its doors for the first time. The first beer that Josh brewed was the Blonde IPA. Josh's years of preparation and hours of brewing both day and night paid off. People loved his beer, and his brewery has done very well.

The Name

Josh loves the European tradition of having a brewery be a family legacy, where the brewmaster is a fifth-generation brewer, and he hopes that is what happens to his brewery. Josh wanted to have his own name in the company name because he wants people to know that he stands behind what he brews. Family matters very much to Josh and Annie, and this concept permeates all that they do.

The Food

Wow! I can't say enough about the food at Pfriem. It is simply stellar. From day one, Josh wanted to have food good enough to go with his fantastic beer. The menu is a take on Belgian and European cuisine made with local Northwest ingredients. Get the Mussels and Fries. The fries are twice cooked, just like proper Belgian pommes frites are supposed to be. Pfriem does wonderful things with duck, and you can never go wrong with the seasonal burger. Ken, my trusty culinary sidekick, loves the baked mac and cheese. Oh, and they have deviled eggs—really good deviled eggs.

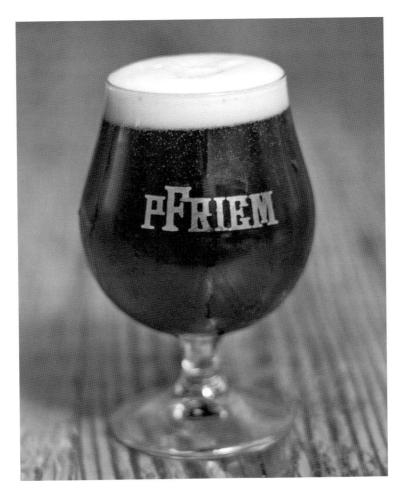

Pfriem Belgian Strong Dark.

For my tastes, Pfriem is a very appealing place to have a beer and a meal. I love the design elements and the look of the brewpub. It is warm and comfortable, with gorgeous dark brown wood tones. Even the light fixtures are super cool. Being located right on the Columbia River is a definite added bonus.

Hood River is an incredible town. When you visit, make sure to stop by Pfriem Family Brewers to have a pint or two and a meal. When it comes to Pfriem beers, I especially love the Belgian Strong Dark, the Blonde IPA and the Belgian Strong IPA. The seasonals are always spot on, and if the CDA is on tap, get it! As they say in Belgium and now in Hood River, *Op uw gezondheid*!

· EUGENE ·

Ninkasi Brewing Company

Jamie Floyd and Nico Ridge opened Ninkasi Brewing Company in June 2006, and it has since become one of the largest craft beer breweries operating in the Northwest.

Jamie Floyd grew up in Cupertino, California, and when it came time for college, Jamie chose to go attend the University of Oregon. Initially, Jamie had wanted to become a journalist, and it was the U of O's School of Journalism and Communication that brought him to Eugene. Jamie ended up majoring in sociology and minored in both women's studies and environmental studies.

Let me say right from the start, Jamie is a very deep thinker, and he is well versed on many different subjects. I could sit and talk with him all day, and we would not run out of topics to converse on. If you ever get the chance to buy Jamie dinner and visit with him, do it! You will have a great time, and you will learn a lot.

Following graduation, Jamie started working at the Steelhead Brewing kitchen in Eugene. A year later, Jamie got a job working in the brewery for

Top: Ninkasi Brewing in Eugene, Oregon.

Left: Jamie Floyd, founding brewer at Ninkasi.

Road Trip!

Steelhead's brewmaster, Teri Fahrendorf. Jamie brewed at Steelhead for ten years, eventually becoming the head brewer.

Jamie had wanted to open his own brewery for a number of years and almost did that twice before opening Ninkasi. The timing turned out not to be right for those first two ventures though, and Jamie never pulled the trigger on them.

The Fateful Question

In January 2005, Jamie was getting ready to leave Steelhead Brewing (something he did a month later) and begin the process of opening his own brewery. This time around, the timing *was* right. One night, he got off work and went to the Beer Stein to have a beer and relax. He ran into Nico Ridge, who asked Jamie a question that changed the course of Nico's life: "If you were to open a brewery, what would you do?"

Jamie answered that question and spoke in broad, general terms. Truth be told, Jamie was already looking at potential places to open a brewery, and he had a comprehensive business plan well on its way to completion. Nico listened to Jamie and provided some great feedback and additions to the rough sketch plans that Jamie was sharing; the two of them had a quite lengthy and enjoyable conversation.

As the conversation wound down, Nico told Jamie, "If you ever decide to do all that, let me know. I would love to be involved." Nico's background in finance made him well suited to be part of a startup brewery. Jamie went home and thought about their conversation. A few hours later, he called Nico and said, "We need to talk." Just eighteen months later, in June 2006, Jamie and Nico opened Ninkasi Brewing Company.

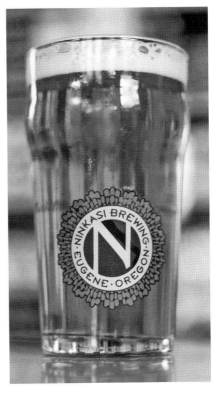

Ninkasi Tricerahops.

Portland Beer Stories

The Beer

Ninkasi makes stellar beer. Its Total Domination IPA is one of its best-selling beers. The Tricerahops Double IPA has legions of fans, and you can never go wrong with an Oatis Oatmeal Stout. It also has some great seasonals, including Spring Reign and Sleigh'r. If you ever get the chance to have a Transcendentale—an ale brewed with lavender and tarragon—do it! What a great beer!

The Name

When people first hear the word "Ninkasi," they often think that it is Japanese, but in fact, it is ancient Sumerian. Ninkasi is the Sumerian goddess of beer. Among the earliest human writings is the *Hymn to Ninkasi*, which is both a prayer and a recipe for beer. Here is an excerpt from an English translation done by Miguel Civil:

> *You are the one who soaks the malt in a jar,*
> *The waves rise, the waves fall.*
> *Ninkasi, you are the one who soaks the malt in a jar,*
> *The waves rise, the waves fall.*
>
> *You are the one who spreads the cooked mash on large reed mats,*
> *Coolness overcomes,*
> *Ninkasi, you are the one who spreads the cooked mash on large reed mats,*
> *Coolness overcomes…*
>
> *When you pour out the filtered beer of the collector vat,*
> *It is* [like] *the onrush of Tigris and Euphrates.*
> *Ninkasi, you are the one who pours out the filtered beer of the collector vat,*
> *It is* [like] *the onrush of Tigris and Euphrates.*

So Ninkasi is named for the ancient Sumerian goddess of beer. I told you that Jamie was smart.

ROAD TRIP!

The Pantheon of Gods

Not many people I run into know about different cultures having different gods. As soon as Jamie told me the origin of the name of his brewery, I began to suspect something. Later, during our interview, Jamie used the phrase "the pantheon of gods," and I knew that my suspicions were correct. Jamie read comic books as a kid.

Let me explain: Thor, a member of the Avengers since *Avengers #1*, is a Norse god. Hercules, who became a member of the Avengers in *Avengers #45*, hails from the Greek family of gods. When you read a comic book with both Norse and Greek gods in it, you get the idea that different cultures have different gods. If you read comics, you know about the pantheon of gods.

Not only was I correct that Jamie *did* read comic books as a kid, but he is also a very sophisticated comic book fan. As a kid, Thor was his favorite comic book hero, followed closely by Batman. Jamie is also a fan of Alan Moore's *Swamp Thing, Fables* and Neil Gaiman's *The Sandman*.

Committed to Eugene and to Its Core Purpose

From before Ninkasi even opened its doors, it was Jamie's goal to build a large regional brewery of which Eugene could be proud. Jamie loves Eugene, and he is very proud that Ninkasi is part of that community.

Go to the Ninkasi website and check out the "Beer is Love" page or the "Environment + Sustainability" page to see all the ways Jamie and Nico have given back and work to fulfill their stated core purpose, which is to "Perpetuate Better Living."

Jamie says that brewing is his art. I have to say, Jamie is a gifted artist, and we are blessed to be able to enjoy his artistry.

Go Visit Ninkasi and Eugene

Take the two-hour drive sometime from Portland down to Eugene, and make a day or a weekend of it. Have breakfast at Off the Waffle, and visit the Ninkasi Brewery for a tour (note: you have to go online and book your tour in advance). Go to the Ninkasi Tasting Room, where you will find special release beers that you will not find anywhere else.

Have lunch at the Sandwich League food cart. It is across the street from Ninkasi, and it has some pretty cool comic book–inspired artwork in its covered seating area. Get the Big O or the Big League. Both are excellent sandwiches.

Also across the street from Ninkasi is Izakaya Meiji Company, an excellent restaurant that has fantastic cocktails. Get the Bourbon and Ginger, bourbon shaken with house-pressed gingerade. The Spicy Tuna Cocktail (not a drink) is yellowfin tuna with avocado, wakame, sesame oil and togarashi. It is served in a small martini glass, and it is stunningly delicious.

· NEWPORT ·

Rogue Ales

What happens to your favorite brewing when the founder wants to retire? Will it sell out? Will it cease to exist? Will someone take over who does not honor what has come before?

When someone is first starting a brewery, the goal and emphasis is to get it open. However, once it has been open for twenty or thirty years, the goal and emphasis becomes keeping it going. Trust me on this: if you are a fan of a certain brewery, who runs that brewery and what their long-term plans are matters. It matters a lot.

I love all the breweries featured in this book, and I hope that twenty years from now, in 2035, all twenty-six of them are still around and still doing what it is that makes them what they are. I am certain that in 2035 Rogue Ales will have grown and changed and that it will still be "Rogue." That will be true because of Brett Joyce, the president of Rogue Ales.

Brett Started Out Washing Kegs

Brett Joyce was a teenager when his dad, Jack Joyce, started Rogue with a few friends. That led to Brett getting to spend five summers in a row washing kegs, pulling mash, washing dishes and cleaning tables. Brett attended Willamette University in Salem, Oregon.

In 1995, following college, Brett took a job at Adidas, first here in Portland near NE 20th Avenue and NE Sandy Avenue and then later in San Diego at

Brett Joyce from Rogue Ales.

the Adidas global golf headquarters. Brett has nothing but great things to say about his time at Adidas. He got to travel the world and learn a tremendous amount about both business and marketing.

In 2003, Brett left Adidas to be part what he had hoped would be a turnaround success story. He went to work at a failing sportswear company. According to Brett, that twenty-month misadventure was an "EPIC failure." He also says that the lessons he learned during those months were invaluable—brutally painful, but invaluable.

In May 2005, he received a call from his dad, Jack. The board at Rogue wanted to see if Brett would come back to Rogue. The timing was right, and Brett was looking forward to working with his dad. Brett was not promised that he would get to lead the company. In fact, it was made clear to Brett that that would only occur if that was going to be good for Rogue. The promise he was made was that he would have the opportunity to see if his working at Rogue was a good fit for both himself and for the company.

Brent spent five years sharing an office with his dad. Brett said that those years were both relationally fulfilling—working with his dad was great—and also very instructive. He learned things sharing an office with his dad that he never would have learned otherwise.

Brett had been with Rogue for two years when the board made a wise decision and made him the president. Since September 2007, Brett has been at the helm, leading Rogue into the future while at the same time keeping Rogue what it is. That kind of leadership takes a deft hand and quite a bit of skill.

People often forget that a brewery is also a business, and the shoreline is littered with businesses that have shipwrecked because the wrong person was allowed to lead that particular ship. If you own a brewery or if you know that someday you will own a brewery, do not drop the ball on the business side of things. It takes more than making great beer for a brewery to succeed.

Great Beer and More

All Rogue beer is made in Newport on the Oregon coast. The company also has a pub in Newport, the Rogue Ales Public House; a two-room bed and breakfast known as the Bed 'n' Beer, where you get beer instead of breakfast; a distillery; and distillery tasting room/pub, Rogue House of Spirits.

In Portland, Rogue has the Rogue Distillery and Public House, Rogue Hall in the heart of the PSU campus and the Green Dragon, a wonderful beer bar with sixty-two taps. Concourse D at the Portland International Airport also has Rogue Pub, where you can get a meal and a Rogue beer. Rogue also has pubs in Astoria, Issaquah and San Francisco.

Barrels, Soda, Cider and Farms

Jack Daniels can no longer say that it is the only distillery in America that makes its own barrels. Rogue now has its own barrel-making facility in Newport, Rolling Thunder Barrel Works. Rogue also makes some really good soda and cider. Ken, my culinary sidekick, is somewhat of a root beer aficionado, and he loves the Rogue root beer. I am partial to the Citrus Cucumber Soda with ice and Rogue Spruce Gin.

Rogue also has two farms. One is in Tygh Valley, Oregon, and it grows barley, grapes, apples and more. This farm also has a floor malting facility. Just south of Portland, in Independence, you will find both Rogue Farms and the Chatoe Rogue Tasting Room. In Independence, Rogue grows

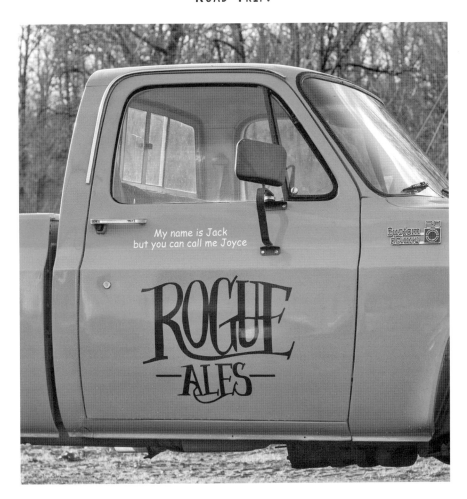

Rogue Farms in Independence, Oregon.

seven varieties of hops, pumpkins, hazelnuts and rye and it even produces its own honey. The company has a hop processing facility at this location as well.

Some warm Portland day, make the hour or so drive down to the Chatoe Rogue Tasting Room. It has twelve taps, and you can usually get Rogue's best-selling beer, Dead Guy Ale. My favorite Rogue beer is the Hazelnut Brown Nectar, and that is on tap as well. At the Chatoe Rogue Tasting Room, you can enjoy a beer and a meal on the outside deck, and then take a leisurely walk around the farm. If you make the trek to Independence, you will have a delightful time. Long live Rogue Nation!

· PACIFIC CITY ·

Pelican Pub and Brewery

In May 2006, Pelican Pub and Brewery opened its doors in Pacific City, a small town on the Oregon coast with a population of about one thousand. Three people were there that day making beer magic happen: Jeff Schons, Mary Jones and Darron Welch.

Jeff Schons and Mary Jones are both husband and wife and business partners. They both grew up in Portland, and they met at work at a construction company. They moved to Pacific City on October 31, 1990, planning on staying there for the winter, but they loved Pacific City and have never left.

In 1995, Jeff and Mary owned a failing restaurant in Pacific City called Fishes Seafood and Steaks. Mary says that restaurant was their university of hard knocks, and they learned all the things not to do in the food business. Up until that point, Jeff and Mary had worked in construction and development.

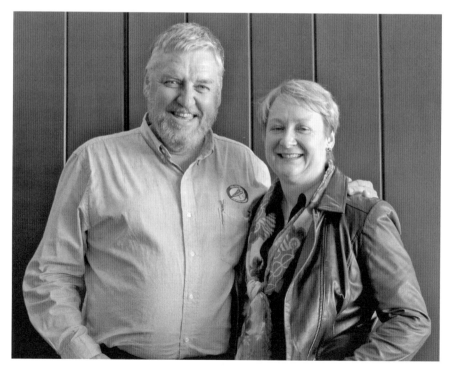

Jeff Schons and Mary Jones, co-founders of the Pelican Pub and Brewery.

Road Trip!

Sitting right on the beach in front of their restaurant was a decrepit, run-down building. The front windows were blown out, and sand was piled up the front of the building so high that you could walk up that sand dune onto the roof and look down through the holes in the roof.

One fateful Saturday afternoon in 1995, they were shown that building by the current owner. This fast-talking gentleman convinced Jeff and Mary that they needed to buy this building, which they did, that very evening. That night they could not sleep. They told each other that this was the dumbest thing they had ever done. They wondered if they could get out of the agreement they had signed a few hours earlier.

That very next morning, Mary was in the back bedroom, and Jeff was in the breakfast nook reading the Sunday *Oregonian*. Jeff yelled out, "It's a brewery!" Mary knew exactly what Jeff meant. They were going to open a brewery in the building. Jeff has seen a snippet about Saxer Brewing in the *Oregonian*, and he knew right then that the building that they had signed for the previous evening would make for an excellent beachfront brewery.

The Index Card

Jeff and Mary signed up for a beer conference happening in Portland on July 26, 27 and 28, 1995. The conference was the Northwest Craft Brewers Conference and Exhibition put on by Stephen Mallery's magazine *Brewing Techniques*. As they were checking in, they saw a bulletin board with nothing on it.

Mary said, "We should post something on that bulletin board because we are going to need a brewer." Mary happened to have an index card in her purse, and they wrote, "Brewer needed for beachfront brewery in Pacific City, Oregon. Please call…" That index card leads us right to Darron Welch.

The Romance Began in Neckartenzlingen

Darron's beer journey started with an exchange student program he participated in following his senior year in high school. He was given the chance to study overseas for one year in Neckartenzlingen, Germany. Prior to that trip, Darron thought that he liked beer. In Germany, he discovered that he loved beer, as long as it was great beer. That year gave him a whole new perspective on what beer could be.

Darron Welch, co-founder and brewmaster of the Pelican Pub and Brewery.

When that magical year in Germany was up, Darron returned to his hometown of Eugene, Oregon, and did two things: he started homebrewing, and he started college at the University of Oregon. While in college, Darron began working part time at John Brombaugh & Associates, which, at the time, was one of the premier organ builders in the United States.

Darron graduated from the U of O with a degree in history, and he took a full-time job at John Brombaugh & Associates and began making pipe organs. In 1993, John began working on a magnificent organ for the Lawrence University Memorial Chapel in Appleton, Wisconsin. This thirty-three-foot-tall organ is made up of forty-two stops, forty-nine ranks and 2,496 pipes. It was built in Eugene, disassembled and shipped to Appleton to be reassembled on site.

Darron lived in Appleton for six months working on the organ assembly project. While there, he found the Appleton Brewing Company, aka the Alder Brau Brewery. In short order, Darron was working there in the brewery on weekends. By the time the organ was completed, Darron had been offered a full-time job in the brewery.

Back to That Index Card

Darron loved Oregon, and he wanted to move home. He also wanted to keep brewing professionally. Darron was able to get one of his beers, the Erich Weiss Bier, accepted to be poured at the 1995 Oregon Brewers Festival (OBF) happening July 28, 29 and 30. Darron decided that he would pay his own way to OBF to see his beer poured and to hopefully find a job brewing back in Oregon.

While Darron was finalizing his trip to Portland, he heard about the Northwest Craft Brewers Conference and Exhibition happening in Portland

ROAD TRIP!

The Pelican Pub and Brewery.

on July 26, 27 and 28 just before OBF, and he added that conference to his itinerary. When Darron went to check in for the conference, he saw a bulletin board with only one thing on it: an index card that read, "Brewer needed for beachfront brewery in Pacific City, Oregon. Please call…"

Darron was not sure where Pacific City was, but it was in Oregon, and the beachfront brewery needed a brewer and that was all that he needed to know. He called the number and left a message.

Jeff and Mary returned Darron's call, and they met up later that same day. Within five minutes of talking with Darron, both Jeff and Mary knew that they had found their brewmaster. Darron became the founding brewmaster and started work at Pelican on September 2, 1995.

The Name

Pelican Pub and Brewery was named after the brown pelican, the state bird of Louisiana. The brown pelican can be found on both coasts, on the Gulf of Mexico and in Pacific City, where Jeff and Mary first encountered them.

The Beer

Today, Pelican beer is made at the Pacific City Brewpub and at the production brewery in Tillamook, Oregon, which opened in September 2013. Pelican has six core beers, including Kiwanda Cream Ale, Imperial Pelican Ale and

Doryman's Dark Ale, as well as three seasonals: Red Lantern IPA, Surfer's Summer Ale and Bad Santa. I love the Bad Santa, a wonderful Cascadian dark ale (CDA).

Pelican also has a number of specialty beers, including the Mother of All Storms, an English-style, barrel-aged barley wine. Each year in November, Pelican has a very special dinner to celebrate the release of that year's Mother of All Storms. That is an event not to be missed.

The Food

You owe it to yourself to go to Pacific City to have a beer and a meal. The food at the Pelican Pub is phenomenal. So many amazing dishes! Here are a few of my favorites: the Pacific NW Cioppino, a spicy Kiwanda Cream Ale seafood broth with prawns, clams, Dungeness crab and fresh fish; the Bleu Cheese Burger, which comes with Doryman's Ale pork belly confit, tomato, arugula and Silverspot IPA aioli; and the Chocolate Peanut Butter Pie, a decadent peanut butter mousse served over a chocolate cookie crust, topped with Tsunami Stout chocolate glaze and served with peanut praline.

Pelican is the only beachfront brewery in the Northwest. There is nothing like being at Pelican, enjoying a Doryman's Dark Ale or, if you prefer, a Kiwanda Cream Ale and watching the sunset over the Pacific Ocean.

· PORT TOWNSEND ·

Finnriver Farm and Cidery

In 2004, Crystie and Keith Kisler, along with Kate Dean and Will O'Donnell, bought a blueberry farm from Elijah and Kay Christian. Today, Keith and Crystie own that farm, now called Finnriver, and it has grown into quite the enchanting enterprise.

Opposite, top: Finnriver Farm and Cidery.

Opposite, bottom: Crystie Kisler of Finnriver Farm and Cidery.

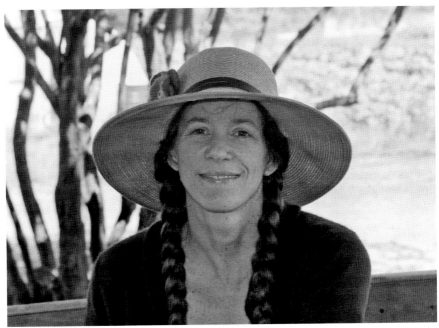

Keith and Crystie met in Yosemite. They fell in love and moved to Seattle. Keith had grown up on a wheat farm in Warden, Washington, near Moses Lake. The longer Keith lived in Seattle, the more he began to long to return to the farm life he grew up with.

Keith had particularly become interested in small organic farms, and that is what drew him and Crystie to Port Townsend, where they eventually found the farm they now call home.

It's Time to Start Pressing Apples

They had been on the farm for five years, making a go of it, when one day, good friend and neighbor Elijah Christian stopped by with a bottle of hard cider that he had made. That bottle of homemade cider sparked Keith's imagination, and he became entranced with both the art and mystery of fermentation.

At the same time, Crystie was pregnant with their second son, Coulter, and spent most of those nine months struggling with morning sickness. By the time that Coulter was born, Keith had a winery license and several hundred gallons of cider working. While Crystie was gestating and birthing Coulter, Keith was gestating and birthing a cidery. Coulter spent the first two years of his life on Keith's back while Keith sorted and pressed apples.

Keith mostly taught himself how to make cider, but along the way he had many allies. Early on, the fine folks at Wandering Anegus Ciderworks out of Salem, Oregon, were very helpful and shared quite of bit of cidermaking know-how with Keith.

Keith and Crystie are a perfect match to oversee Finnriver Farm. Keith is the driving creative spirit, and the culture of resourcefulness he grew up with in Warden serves him to this day. Crystie provides the entrepreneurial spirit. She is quite the dynamic businesswoman and a very good storyteller.

Farm and Cidery

Today both the farm side and cidery side of Finnriver are doing well. The farm produces blueberries, apples, raspberries, strawberries, vegetables, chicken eggs, duck eggs and pastured pork. The cidery makes some of the best hand-crafted cider that you will ever have. In addition to cider, Finnriver also makes brandy dessert wines and port-style spirited wines.

I love a number of the cidery creations. Some of my favorites are the Fire Barrel Cider (aged in bourbon barrels), the Sparkling Black Currant Cider, Black Currant Wine, the Pommeau Apple Wine and the Cacao, a pear wine with apple brandy and cacao. Trust me on this: add the Finnriver Cacao to Fort George Cavatica Stout. The combination is wonderful. Many thanks to Tim Ensign for introducing me to this cocktail that I call Chocolate Darkness.

Jana Daisy-Ensign

You can't properly tell the Finnriver story without mentioning its Portland-based brand ambassador, Jana Daisy-Ensign. If you attend a Portland-area cider event or beer festival, you are likely to run into Jana or someone from her team. They will be there at the Finnriver booth describing the wonders of Finnriver and giving you the opportunity to sample their detectable cider. I don't think that Finnriver would be where it is now without Jana.

Jana does a stellar job representing Finnriver both in the Northwest and across the United States. I have seen Jana excitedly telling the Finnriver story at noon when a festival begins. As the day wears on, most of the people working a booth at a festival get tired and (understandably) a little less enthusiastic. Stop in and see Jana at 7:00 p.m., and she will be as positive and radiant as she was at noon.

Jana shares the values that embody Finnriver—so much so that along with her husband, Tim Ensign, she works a farm of their own, the Earth and Sky Farm. One fun note: Tim works for Fort George Brewery. He is its "El Jefe of Sales and Distribution." I have met a number of amazing people in the beer and cider community, and Tim and Jana are two of my favorites.

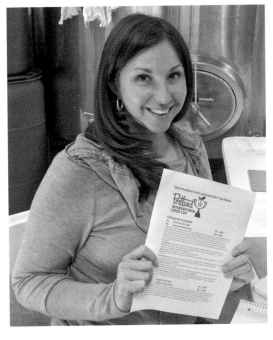

Jana Daisy-Ensign, a Finnriver brand ambassador.

Go Visit Port Townsend

I love Port Townsend! It is a very charming city and well worth a weekend visit. Of course, if you go, make sure that you visit Finnriver Farm and Cidery. There are a few other places I recommend that you visit while you are in Port Townsend. Alpenfire Cider and Port Townsend Brewery are great stops. For lunch, get some fruit, cheese and bread at the Port Townsend Food Co-op, stop by the Wine Seller and have picnic out at Fort Worden State Park.

Have a fantastic dinner or breakfast at Sweet Laurette Café and Bistro. If you get a chance to meet Laurette Feit, you will instantly know why her farm-to-table food is so good. For drinks, make a stop at the Cellar Door, which makes great cocktails. If you need a beer at midnight and you are looking for something fun and quirky, check out the Pin Bar, aka Middletown Dreams. It is always open until 2:00 a.m.

I recommend that you stay at one of the wonderful bed-and-breakfasts in Port Townsend. One of my favorites is the Old Consulate Inn. Cindy and Nathan are fantastic hosts, and you will have a splendid time.

It is wonderful to visit Port Townsend in the summer and fall, but for me, the best time to visit Port Townsend is in the winter. It is even more charming in the winter, and you will get even better service because most businesses are delighted to see you during this typically slow season.

It is fitting that the final road trip city and story I cover is Portland Townsend and Finnriver Cider. Our very next section continues with four Portland-based cider stories!

Beer Writer's Perspective
D.J. Paul

D.J. Paul is a major contributor to Brewpublic.com and can also be found contributing to Northwest Brewing News and its "Portland Pint" column. He is a member of the North American Guild of Beer Writers.

Portland is a very special place for those who truly appreciate craft beer. This city is very in touch with beer, and the brewers who brew these tasty libations are treated like rock stars. Craft beer is part of the culture. Heck, our city is commonly referred to as Beervana, and rightfully so. On any given night, there's sure to be some sort of beer event that takes place here. Sometimes the calendar is so jampacked that it's impossible to hit all of the events that are taking place.

For those who are planning a trip to Portland for the first time or for their second or third time, it's definitely worth the effort. With close to sixty operating breweries within the city limits and multiple places to drink great craft beer, this city is ripe for exploring.

When pressed on listing the top spots for an out-of-towner, our number one go-to spot has to be Horse Brass Pub. Founded in 1976 by two brothers, Don and Bill Younger, this pub is the foundation to Portland's craft beer movement. The "Brass" offers well over fifty taps featuring some of the best beers from Portland and the rest of the Pacific Northwest. And if you're a fan of fish and chips, make sure to order some to keep the tasty beers at bay.

Coming in second is Bailey's Taproom, located in the bustling Portland downtown next to two Portland institutions, Mary's Club and Tugboat Brewing. With twenty-four rotating taps featuring both the well-established breweries and some of the trendy newcomers, Bailey's is the spot to find many beers being tapped for the first time in Portland. Its business has grown enough that it now has a second location. One doesn't have to travel that far to reach it: it's located directly above. The Upper Lip is fast becoming a well-traveled spot for those looking to share a nice vintage bottle or quaff from the well-selected, rotating draft list.

Regarding beer events in Portland, the largest by far is the annual Oregon Brewers Festival. Held the last full weekend in July when the weather is spectacular, this is a definite don't-miss festival. When the days are long and the sun is bright, the Oregon Brewers Festival brings out some of the best beers one can fill his mug with.

Beer Writer's Perspective

I would be remiss if I did not mention the longest-running craft beer week in Portland. Brewpublic's Killer Beer Week is held each October with events taking place all over town. Killer Beer Week is geared toward both the casual craft beer fan and the hardcore beer geek. The week features many various events, but one highlight is Killer Pumpkin Fest held at Green Dragon. The week culminates with Killer Beer Fest held every year at the aforementioned Bailey's Taproom. This fest is not for the faint of heart. Some of the best cellared beers, along with the freshest of hopped-up beers, are featured at this annual event. Killer Beer Week is surely not to be missed.

Every day I am blessed to wake up and be part of the great beercentric city of Portland. Craft beer is in my blood.

CIDER

• BUSHWHACKER CIDER •
America's First Cider Pub

Portland is the epicenter of the growing cider revival happening right now in America. I say "revival" because there was a time early in our country's history when cider was the most popular alcoholic beverage. Portland is currently home to more than a dozen cideries, and we drink more cider here in Portland than they do in the entire region of New England.

Would Portland Support a Cider Pub?

It is fitting that Portland is home to America's first cider pub. Jeff and Erin Smith opened Bushwhacker Cider in the fall of 2010, and they been excellent ambassadors for cider ever since.

Jeff began "homebrewing" cider in 2004. The more cider he made, the more the more he fell in love with cider. Jeff also enjoys beer, and he and Erin would occasionally find themselves at BeerMongers. By 2009, Jeff and Erin began to get the idea that maybe they could have a cider pub that served cider fans the way BeerMongers served beer fans. Sean, the founder of BeerMongers, soon heard of this idea and was very encouraging and supportive.

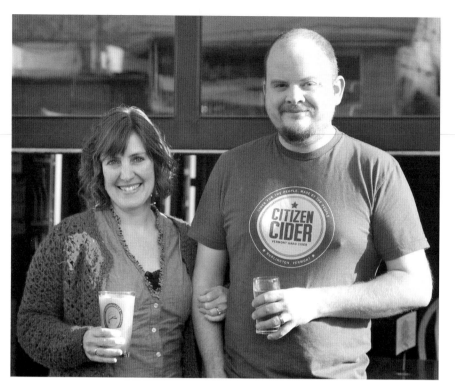

Erin and Jeff Smith, founders of Bushwhacker, America's original cider pub.

By the fall of 2010, Bushwhacker Cider was open. It started out with eight ciders on tap and thirty-five different ciders available in bottles. The question on the table was would Portland support a cider pub? The answer was a resounding yes.

Today, Bushwhacker has two locations. The original location is now known as Bushwhacker Brooklyn (it is located in the Brooklyn neighborhood of Portland). This location has over 350 different ciders available in bottles. Some have called Bushwhacker Brooklyn the Belmont Station of cider. Bushwhacker Brooklyn is also home to the Bushwhacker cidery.

The second location—Bushwhacker Woodlawn, located in the Woodlawn neighborhood of Portland—opened in the spring of 2015 and has fourteen taps and a full kitchen with an outstanding menu. Bushwhacker Woodlawn is very well appointed and is a great addition to the Portland food scene as well as being a place that will continue the Bushwhacker tradition of celebrating and promoting cider.

Cider

Cider is taking off both across the country and especially here is Portland. Cider fans everywhere should raise a glass to Jeff and Erin. They bushwhacked a trail through some pretty thick woods and have helped spark the cider revival unfolding before our very eyes.

· CIDER RIOT! ·

Growing Up Drinking "Proper Cider"

Abram Goldman-Armstrong started Cider Riot! in April 2013. Abram grew up in the "woods of Yamhill County," west of Pike, outside of the city of Yamhill. As Abram was growing up, he spent quite a bit of time at White Oak Cider, where they made West Country English-Style Cider. Abram's dad was good friends with Alan Foster, the founder of White Oak.

From the time that he was very young, Abram knew that proper cider was made from cider apples, aged on oak and very tannic. Cider Riot's 1763 cider is modeled on the White Oak cider that he enjoyed growing up.

Abram attended Macalester College in St. Paul, Minnesota. It was there that Abram made his first batch of cider. *Profane Existence* was a Minneapolis punk fanzine, and it had a recipe in the back for Punk Rock Cider. Abram "scrumped" (stole) some apples from the dining hall, got some champagne yeast from Northern Brewer Homebrew Supply, borrowed a carboy from someone who home brewed across the hall in the dorm and fermented it for two weeks. Abram has been making cider ever since.

One fun note: back then, no one sold whole hops in Minneapolis. Every college break when Abram came home to Oregon, he would go to FH Steinbart, pick up a bunch of Cascade hops and fill his luggage with them to take back to his homebrewing friends at Macalester. When you bring the hops, you get to drink the beer made from them.

Abram came back to Portland in 1999, and he started applying for jobs at local breweries. When he was at the Hair of the Dog looking for work, he was told about the Oregon Brew Crew. Abram started homebrewing, joined the Oregon Brew Crew and was elected president at the age of twenty-one.

Starting in the fall of 2008, Abram took a gang of his friends out to the woods of Yamhill to make cider. By then, White Oak Cider was closed, but the cider apple orchard was still there making beautiful cider apples. With Alan Foster's permission, Abram and his friend would spend a day picking

Abram Goldman-Armstrong, founder of Cider Riot!

apples and hand pressing them. Each year, Abram would make about sixty gallons of cider.

This annual cider-making event went on for five years. Abram's friends would always tell him that his cider was excellent and that he should make cider commercially. He just did not see how he could do that. That all changed in February 2013.

Abram was invited to a cider tasting at Reverend Nat's home. While there, Abram got to see the cider-making setup that Reverend Nat had in his basement. As soon as Abram saw that cider-making setup, he said to himself, "That I can do!" Two months later, Abram started Cider Riot!

Today, you can get Abram's cider at local Portland grocery stores, food co-ops and bars across the city. Abram makes great cider. Some of my favorites include his 1763, the Everybody Popo hoppy cider and the Never Give an Inch blackberry cider. By the way, the label for Never Give an Inch features one of John Foyston's "rusty truck" oil paintings.

CIDER

· PORTLAND CIDER COMPANY ·

A Cider Love Story

Jeff and Lynda Parrish started Portland Cider Company in the fall of 2012. In February 2014, they opened their tasting room in Oregon City, and in the spring of 2015, they opened the Portland Cider House. I love seeing them succeed. They are some of the nicest people that you could ever meet.

Does She Like Cider?

Jeff loves cider. A number of years ago, he discovered "real" cider, what some people call West Country–style cider like they have in Somerset, England. In 2006, he met Lynda. She seemed perfect, but what Jeff did not know was whether she liked cider. Even back then, Jeff hoped to some day have a cider business of his own, and he did not see himself in a long-term relationship with someone who did not like cider.

One of their first dates was a picnic to Washington Park here in Portland. Washington Park is a large urban park with picnic areas, playgrounds and lots of forested trails. It is also home to the rose garden, the Oregon Zoo and much more. It is great for a romantic picnic and a stroll.

In his picnic basket, Jeff packed a very "scrumpy" cider. If you have never had cider before, you might not like a scrumpy cider. Scrumpy cider tends to be more tannic in flavor and higher in alcohol content than most commercial ciders. Jeff wanted to find out right away whether he and Lynda might be a good match.

At fate would have it, Lynda grew up in Somerset, England, and she had grown up drinking scrumpy cider. For her, it was a much-welcomed taste of home. Jeff and Lynda were a match made in cider heaven. They married in 2009. Another thing that they had in common was a desire to be self-employed, and they both had a realistic perspective on what it took to start a business and see it succeed.

Jeff and Lynda were perfectly matched both for a romantic relationship and for a business partnership. In 2012, they launched Portland Cider Company, and they have been working very hard to grow their business and their efforts are paying off.

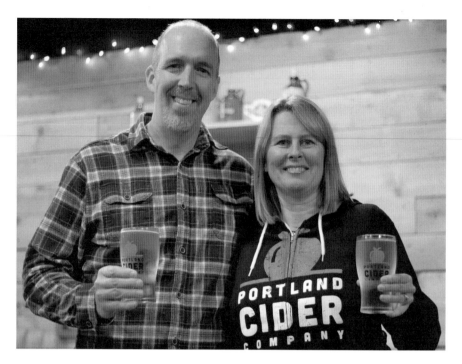

Jeff and Lynda Parrish, founders of the Portland Cider Company.

Go to the Portland Cider House

Jeff wisely knows that not everyone is going to be ready to enjoy the scrumpy West Country cider that he loves. As Jeff shared at the 2014 Portland Spring Beer and Wine Fest, he makes "cider that is easy to drink." If you are not sure whether or not you like cider, go try Jeff's Kinda Dry or Sorta Sweet. I am willing to bet that you will like one of those two ciders.

Better yet, go to the Portland Cider House on SE Hawthorne Boulevard and SE 36th Avenue. There are twenty-eight cider taps there. The Portland Cider House has its own ciders on tap, as well as many other local Northwest ciders. You can get a flight and find the cider that suits your fancy. If it is the holiday season, look for Santa's Sauce. It is an incredible cider made with cinnamon, cardamom and a touch of cayenne.

CIDER

· REVEREND NAT'S HARD CIDER ·

For the Sake of Cider

Nat West is a flat-out creative genius. I am convinced that had he become a brewer or a winemaker instead of a cider maker, he would have as much notoriety in those fields as he is getting now in the cider world. The cider world is very lucky that Nat's neighbor had too many apples back in 2004.

In 2004, Nat used some of his neighbor's surplus apples to make cider for the first time in his life. That first year, Nat made five gallons of cider. He loved it. He kept making more and more cider each year until finally, in 2010, he made five hundred gallons of cider in his basement.

Sitting at the Table

The summer of 2011, Nat was sitting at the table talking with his wife when he decided that he was going to become a professional cider maker. The cider that he was making was very well received. People who knew cider loved it. People who did not know cider loved it.

Nat could see that the cider industry was exploding, and he knew that over the next ten years, many people would be checking out cider. If they liked what they tasted, they might possibly become cider drinkers. If they did not like what they tasted, they might not give cider a second chance.

Nat has grown to love cider, and he decided that for the sake of cider, he would throw his hat into the ring and become a professional cider maker. So did the cider industry really need Nat West? The proof is in the pudding. Reverend Nat's

Sarah and Nat West.

Cider is one of the fastest-growing cider companies in the Northwest, and each week Nat converts more and more people to cider.

Nat makes more traditional cider, and he also makes some really different stuff. His approach creates a wide net that draws in a lot of people. As I said, Nat is a flat-out creative genius.

Great Name, Great People, Great Cider

As they were talking about a name for Nat's cider endeavor, Nat's wife, Sarah, said, "You are always preaching about cider and trying to proselytize people to cider. You should call it Reverend Nat's." The name was perfect. Done. Way to go, Sarah!

You can tell a lot about someone by who chooses to run with him. Nat has some amazing people on his staff, like Carlyon Winkler, Gemma Schmidt, Lia Wallon and Jim Bonomo. I have had the pleasure of getting to know these people, and they are incredible human beings. Great leaders attract a great team. Reverend Nat's Hard Cider is just getting started. You just watch what is going to happen over the ten years.

I am huge fan of Revered Nat's. I love its cider. I love its marketing. I love how the company uses social media. I love how it uses events to create buzz. Nat gets it. Nat know storytelling. If you want to launch a start up and have it succeed, you would do well to carefully watch what Nat does and learn from it.

Drink These

Here are a few of my favorite Reverend Nat's ciders: Deliverance Ginger Tonic, made with cider, ginger juice, lemongrass, lime juice and lime zest; Hallelujah Hopricot, with cider, apricots and hops—damn, this is good stuff; and Padre Nat's Tepcahe, with fermented pineapple—no apple, just pineapple. Mix it with so many good things: ice cream, champagne, New Deal Hot Monkey pepper vodka, coconut rum and tequila.

Reverend Nat's Hard Cider will change the way you think about cider. Amen.

Beer Personality's Perspective
Chris Crabb

I am a proud, card-carrying SNOB (supporter of native Oregon beer). I have been working in public relations and events in the craft beer industry in Oregon for more than twenty years. By chance, I stumbled into it when I was barely of legal drinking age, and I've watched it grow and evolve. I still fervently love it to this day.

Today, there are likely as many festivals as there are breweries in town; there is easily a beer festival taking place every month, if not every weekend, somewhere in the city. But that wasn't always the case. I started working in this industry in the spring of 1995, and there were really only two beer festivals in Portland: the Spring Beer & Wine Fest had just made its debut, and the Oregon Brewers Festival was celebrating its eighth year. The Winter Ale Festival would make its first appearance later that year in December (it would later be renamed the Holiday Ale Festival).

The Oregon Brewers Festival is the granddaddy of them all. Featuring two large tents set up on a long grassy stretch paralleling the Willamette River in the heart of summer, it epitomizes the beer festival atmosphere. Add eighty thousand people over the course of five days and you have an epic celebration. With its free admission and mug/token, taster/full purchase system, it has set the stage for many of the beer festivals you attend today. For some, the OBF is a right of passage, for others it's a bucket list event and for many, it's a crowded nightmare. But love it or hate it, the festival has drawn international attention and over the years has brought hundreds of thousands of people—and their tourist dollars—into the city, all for the love of craft beer.

Our beer festivals are as diverse as the beer we drink, but each has its niche. To stereotype, the OBF is the party festival. The North American Organic Brewers Festival is the hippy festival. The Holiday Ale Festival is the beer geek festival. And so it goes. But what's fabulous is that there truly is a beer festival for every palate. Like rich, roasted coffee with your beer? Head to the NW Coffee Beer Invitational. Looking for a fruit beer? Try the Fruit Beer Festival. Are rye beers your thing? There's a Rye Beer Festival for that. Want beer brewed with hops picked fresh the same day? We've got a Fresh Hop Festival (actually, we have a few of them). And don't forget Puckerfest with its sour, wild and funky beers.

Some cities have a craft beer week when they celebrate their beer culture. We tried that; a week wasn't enough. Portland Beer Week runs eleven days; as

for the state, we had to declare Oregon Craft Beer Month to accommodate the more than five hundred beer-themed events that take place in July.

These festivals take place in breweries, in tasting rooms, in bottle shops, in growler stations, on city streets, in city parks and in public spaces. How great is it to live in a city where we can throw a stone and hit a beer event? It's pretty damn amazing.

I love the camaraderie of our craft beer industry. It truly is an industry where—for the most part—competitors are friendly and supportive of one another. I admire the fact that new beer festivals start up all the time in Portland, yet rarely do they fail. Oregonian beer lovers go out of their way to help these events not only survive but also flourish.

Beer festivals got their start in Portland in the summer of 1988 with the OBF, and we've never looked back. As Plato said, he was a wise man who invented beer. But perhaps he was a wiser man who invented the beer festival. Cheers!

Beer Writer's Perspective
Wolf Linderman

A craft beer lover for decades, Wolf Linderman resides in the Alberta Arts District in Northeast Portland. When he's not manning a cubicle at his day job, he is either drinking beer or writing about it on his blog, Beer Guy, PDX, http://www.beerguypdx.com.

I'm a self-proclaimed Beer Guy. I just love the stuff—some people might say obsessively. Okay, the "some people" is mainly my always supportive wife, Puanani, who is not a beer lover but nevertheless gets dragged into every taproom, beer bar, brewery and festival tent found anywhere in Portland and surrounding environs. Of course, the craft beer culture in Portland makes it very easy to become an obsessed Beer Guy or Beer Gal. Living close to the heart of this fantastic jewel of the Pacific Northwest, I can practically throw a rock from my front porch (in any direction) and hit a brewery. There are at least a dozen world-class craft breweries within a reasonable walking distance or short bus ride from my home, but it is not just that astounding proximity and the unprecedented large number of breweries that enthralls me. Portland's beer culture is truly unlike anything I've experienced anywhere else.

What is so unique about Portland's beer culture? Unlike most other U.S. cities of this size, the beer culture in Portland is an integral and inseparable part of the character of virtually everyone who lives here. It's the real deal, and I'm not exaggerating for dramatic effect or taking poetic license. Even Portlanders who don't drink the stuff will list "beer" as one of the city's most important industries, tourist attractions and cultural cornerstones. No matter what any skewed newspaper poll may tell you, Portland is Beer City, USA. We all know it, and to such a degree that it only makes us chuckle when someone asserts otherwise.

There is an incredible sense of community surrounding the beer culture in Portland that one needs to experience firsthand to fully understand. I know that sounds obtuse, but it's the truth. Brewers, publicans and beer drinkers form a symbiosis here that is not only supportive but is downright celebratory. Yes, I think that's as close as I can come to describing it: Portland doesn't drink beer; Portland celebrates beer.

Just over two years ago, I attended my very first bottle share in Portland. I saw a tweet announcing a get-together at a local brewery, just a few beer geeks sharing some brews and tasting experiences. It sounded like fun, so I brought a bottle of something way too expensive and—yes—dragged my

wife along with me. The "event" consisted of five guys hunkered around a table outside a closed brewpub on a very rainy day. I had some very tasty beers, but I also made some amazing friends.

That little group of geeks grew with every monthly bottle share, to the point that last month's event really was just that—an event. We now expect crowds of anywhere from forty to fifty-plus craft beer lovers, and two events are planned for January 2015. Keep in mind that these bottle shares are not money-making ventures! Admission is free as long as the participants bring a bottle of craft beer to share, and unlike that first bottle share I attended, we are now actually welcome inside the taprooms and breweries that host us. What's truly amazing is that even with the ever-growing popularity, it's still just a group of Portland beer lovers coming together to appreciate the amazing craft beers produced in Portland and Oregon and beyond. It's kind of like an incredible craft beer flash mob, and to me, it epitomizes the spirit of Portland's beer culture.

Portland is a big/little city in many ways. It's the kind of town where you can run into your favorite brewer at the hardware store and ask him, "What's brewing?" It's the kind of town where special/seasonal beer releases are as anxiously anticipated as Christmas or the debut of a blockbuster film. It's the kind of town where the bartender at your favorite taproom really does know your name. It's the kind of town where "beer snob" is a term that is used tongue-in-cheek because most craft beer lovers here are more interested in proselytizing the awesomeness of Portland beer than lording their expertise over others. (I would not consider myself to be a "beer expert" by any stretch. There are brewers in this city who are absolute brewing geniuses. I've done a little homebrewing, and I have just enough knowledge to be considered dangerous. I'm really just a fan and a fervent advocate of Portland beer culture.)

As I mentioned, I'm a Beer Guy. I like to sample lots of different beers, so you will often find me on a stool in a taproom. Apex on Southeast Division is one of the best beer halls in Portland, in my opinion. The fifty rotating taps and a casual vibe keep me coming back. Fifteenth Avenue Hophouse is right on my Number 8 bus route home. (This is environmentally conscious PDX, after all, and I don't own a car.) Hophouse has at least two dozen rotating taps and always has something that pleases my palate. Truthfully, there are so many wonderful spots to enjoy a craft beer in Portland that I doubt I'll ever get to all of them!

SEVEN MORE PORTLAND BEER STORIES

FROM HOMEBREWING TO PINK BOOTS

• LEE HEDGMON •

2015 President of Oregon Brew Crew

Lee is a Portland native who started out her beer journey enjoying a Ruby at McMenamins. That was the very first beer that she ever had. Lee then moved on to helping a friend homebrew. Lee did not homebrew herself at that point; she mainly stood around and drank beer while her friend did the homebrewing. In 2001, she moved to Minneapolis to pursue a PhD at the University of Minnesota.

It was there in Minnesota where she began homebrewing for herself. Midwest Supplies in St. Louis Park was her home brew shop. The reason that she began homebrewing once she got to Minnesota was that she discovered that the beer scene there was not quite like the beer scene here. She started making the beers that she missed.

Back to Portland

In 2009, Lee came back to Portland, and in 2010, she joined the Oregon Brew Crew, Oregon's oldest homebrew club. Lee did not know anyone in the Portland beer community when she moved back to Portland. Lee was welcomed with

Lee Hedgmon, 2015 president of Oregon Brew Crew.

open arms, and she soon found the Oregon Brew Crew to be an excellent place to make friends and sharpen her brewing skills.

Lee then began volunteering at the various beer festivals and events supported by the Oregon Brew Crew. The awesome beer festivals that happen in Portland could not occur without the people who volunteer at these events. The Oregon Brew Crew encourages its members to serve at Portland beer festivals such at the Portland Spring Beer and Wine Fest and the Oregon Brewer's Festival.

In 2013, Lee became the volunteer committee chairperson. This position coordinates the Oregon Brew Crew volunteers who serve at the festivals. Lee held this position for two years, and at the end of 2014, she was elected president of the Oregon Brew Crew.

In case you were wondering, Lee is the first female president of the Oregon Brew Crew and the first African American president as well. Lee takes all of this in stride. She is appreciative that at least in Oregon, her experience has been that being a woman and an African American has not been a hindrance to being of the Portland beer community.

Lee is aware that across the country, generally there are not many women or African Americans involved in the craft beer scene, and one of her passions is to let people know that if you want to be a part of the craft beer movement—whether you are male or female, black or white—there is a place for you.

Lee loves the Oregon Brew Crew, and she is a huge fan of the Portland beer community. I believe that the Oregon Brew Crew is in great hands and will greatly benefit from Lee's continued influence.

So You Want to Homebrew?

I asked Lee how someone who wanted to homebrew should get started. Her advice is first to buy a homebrew kit and get started brewing. Once you have

done a little homebrewing and you are familiar with a few brewing terms and concepts, join a local homebrew club.

Lee shared with me that if you are a homebrewer and you want to brew better beer, you need to give your beer to someone you don't know. That is the person most likely to give you honest feedback. Your friends might be afraid to do that for fear that if they criticize your beer, they won't get to help you drink it anymore.

If you live in Portland and you are thinking of homebrewing, I would encourage you to go to the Oregon Brew Crew website and get involved. The Oregon Brew Crew is a very important part of the Portland Beer community, and for the past thirty-five years it has been shaping and improving that community.

· LISA MORRISON ·

Portland's Own Beer Goddess

Lisa Morrison is a true craft beer champion. Lisa started out as a craft beer fan and then became a homebrewer. Eventually, she became a beer writer writing for many publications including *Celebrator*, *All About Beer* and *Zymurgy*.

For more than six years, Lisa was the host of Beer O'Clock!, an hour-long regional radio show. She is the author of the excellent book *Craft Beers of the Pacific Northwest*, she is a well-traveled beer judge and in 2013, she became the co-owner of one of Portland's best bottle shops, Belmont Station. The craft beer community owes a big thanks to a fateful care package. Here is why.

A Mini Keg of Dinkel Acker: Lisa's Aha Beer Moment

When Lisa was in college at Colorado State, the people on her dorm floor soon learned to watch for the awesome care packages that Ralph (who also lived on their floor) would get sent to him from his mother in Manhattan. One day the care package contained a mini keg of Dinkel Acker. Lisa tried and loved that beer, and she discovered that the world of beer was vast and wonderful. From that beer on, she began to search out amazing beers.

Following college, Lisa and her husband, Mark, moved to Portland because Mark got a job here. Mark headed to the Northwest a few weeks before

Lisa Morrison, Portland's own Beer Goddess.

Lisa did, and their first Portland-area apartment was out in Gresham. Mark called Lisa and told her that he had found a small brewpub that brewed its own beer (the McMenamins Highland Pub). Mark soon found that Portland has quite a bit of local craft beer.

When Lisa joined Mark in the Northwest, they dove into the Portland beer scene. They began homebrewing, they joined the Oregon Brew Crew and they began attending beer festivals. One day while attending the Portland Spring Beer and Wine Fest, Lisa met legendary Portland beer personality Fred Eckhardt. Lisa remembers thinking, "Fred is a beer writer. I am writer. I could write about beer." Thus Lisa's beer writing journey began, and craft beer fans everywhere are better for it.

In 2014, Lisa was honored in Belgium for her service to the global beer community in general and to Belgian beer specifically. She was knighted by the Belgium Brewers Guild as a Knight of the Brewers Mash Staff. Portland is very lucky to have Lisa living right in our community. She is a true craft beer champion.

Belmont Station

Belmont Station is a Portland-area bottle shop that is to craft beer what the Tyler Mall Farrell's candy store was to me when I was in grade school. If you are new to Portland or if you are visiting our beloved city, you might be confused as to why a bottle shop located on Stark Street is called Belmont Station. Here's the deal: Belmont Station used to be located right next door to the Horse Brass Pub on Belmont before it moved to the much larger location on Stark Street.

It generally has over one thousand different bottles on hand at any one time. You can go to the website to see an up-to-date listing of what is on the shelves. Every bottle in stock is listed alphabetically. Belmont Station also has twenty-three taps, and food service is provided by the Italian Market food cart, whose story you can find in my first book, *Portland Food Cart Stories*.

One fun note: a number of Portland beer luminaries have worked at Belmont Station over the years, including Teri Fahrendorf, Alex Ganum, Ben Love, Abram Goldman-Armstrong, Ezra Johnson-Greenough and Brian Butenschoen.

· RODNEY KIBZEY ·

You Can Make Beer at Home?

Rodney Kibzey is one of the best homebrewers in America, and he calls Portland home. Here is his story.

In 2002, Rodney was living in Chicago, and he and a friend took a brewery tour in Milwaukee, Wisconsin. Rodney had never been to Milwaukee before, and he had not really paid that much attention to beer. On that trip, Rodney found himself at Lakefront Brewery, and he was enraptured by the experience. He loved all of it, including the aroma, the ambiance and the beer.

His friend made an offhanded comment to him, saying, "You know, you can make beer at home." Rodney repeated the statement as a question, "You can make beer at home?" His friend assured Rodney that he could really do this. When Rodney got back to Chicago, he got a home brew kit and "went crazy with it."

Rodney then joined a home brew club, the Urban Knaves of Grain, and he also joined the Chicago Beer Society. Rodney began to immerse himself

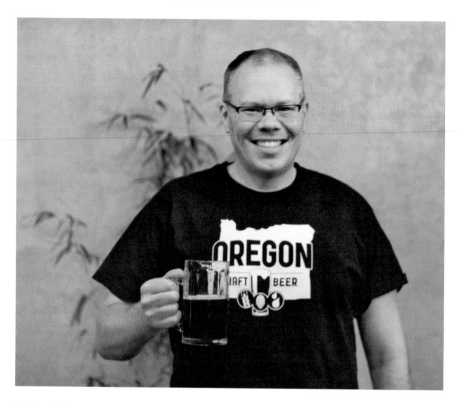

Rodney Kibzey, one the best homebrewers in America.

in craft beer and homebrewing. He completed the Beer Judge Certification Program (BJCP) in 2003, and he judged his first home brew event that same year. Rodney went all in.

An Award-Winning Homebrewer

If you ever wonder why people say that Rodney is one of the best homebrewers in the United States, just check out his homebrewers competition resume. Rodney has won Best of Show in dozens of home brew competitions in places like Iowa, Georgia, Alaska and Victoria, British Columbia.

Rodney won the Samuel Adams LongShot American Homebrew Competition twice. To date, he is the only person to have done that. Rodney won the Midwest Home Brewer of the Year, a yearlong competition that has twelve to fourteen judged events. To win this award, you have to enter home

brew competitions throughout the Midwest, in places like Illinois, Iowa, Minnesota, Michigan, Ohio and Indiana.

Locally, in 2014, Rodney won the Widmer Collaborator homebrew competition put on by Widmer Brothers Brewing and the Oregon Brew Crew. Rodney loves to enter competitions, and his annual rhythm is to homebrew through March. At his home, he has seventeen taps, and by April each year, those seventeen taps are stocked with beer, cider and mead that Rodney has brewed.

The Beer Was the Bonus

Rodney moved to Portland in 2013. He had visited here previously for the first time while attending a National Homebrew Competition event in Seattle. He drove down to Portland and fell in love. When his friends in Chicago heard that he was moving to Portland, they would tell Rodney that he was moving for the beer. However, for Rodney, the beer was the bonus. He moved here primarily for the weather, the outdoors and the people.

Don't be mistaken—Rodney loves the Portland beer scene. When he moved here, he felt like a kid in a candy store. If you were to visit Portland from out of town for what he calls a "beercation," he would suggest that you consider visiting a number of places including but not limited to Hair of the Dog, Cascade Brewing Barrel House, the Commons, BeerMongers, Belmont Station, the Horse Brass, Roscoe's and Bailey's Taproom.

Advice for Homebrewers

Rodney has some excellent advice for people want to start homebrewing.
- Keep it clean. Clean equipment is the foundation of good beer.
- Keep it simple. Don't try to brew with too many ingredients.
- Get a system that works for you. Sometimes when people start out homebrewing, they get a homebrew system that is too fancy and does not serves them.
- Join a local home brew club.
- Lastly, Rodney says DO NOT make the biggest mistake that he sometimes sees new homebrewers make: they quit too soon. Stay with it, and in short order, you will be brewing beer that is actually good!

• SARAH PEDERSON •

Escaping the Cubicle for a Much Better Life

Sarah Pederson, founder of Saraveza Bottle Shop and Pasty Tavern.

Sarah Pederson opened Saraveza in October 2008. Saraveza is consistently ranked not only one of the best beer bars in Portland but also one of the best beers bars in the country.

Sarah grew up in Shawano, Wisconsin, not far from Lambeau Field. If you have ever wondered why Saraveza is a Packers' bar, wonder no more. Saran loves the Packers! When Sarah was a kid, her family would take winter vacations to the Upper Peninsula of Michigan, aka the UP. The very popular local dish in the UP is the pasty. A pasty is a folded "pastry" that is savory and filled with meat and/or vegetables.

Sarah went from Shawano to Minneapolis to Los Angles to Portland, arriving here in 2000. At the time, she was doing PR for a major corporation, but Sarah was not cut out for cubical land. It felt like it was killing her, and she began to think about quitting, not knowing what she would do next.

About this time Sarah was at the Horse Brass, and she ordered a cask-conditioned Hair of the Dog Fred, not realizing what it was she had just done. The beer was served to her in a wine glass, and that perturbed her. Why is this beer in a wine glass? Sarah tasted her beer, and as she says, "It changed my life." Sarah never knew that beer could be so good. From then on, Sarah began to truly explore craft beer.

Seven More Portland Beer Stories

Pix Patisserie and Craft Beer

Sarah did end up quitting her corporate job. She just could not do it anymore. People who love the corporate life are not likely to understand, but people who have felt suffocated living in cubical land will know exactly why Sarah had to quit. She did so to save herself.

Moving to Portland, Sarah learned that here in the Rose City, you are encouraged to pursue your dreams. You come to learn that here in Portland, "you don't have to do what you are supposed to do." You can do what fits who you are.

Sarah needed income, and she started working at Pix Patisserie for her friend Cheryl Wakerhauser. While Sarah did this job, she also began to explore the possibility of being a brewer. She graduated from the American Brewer's Guild, interned at Hair of the Dog and worked in the cellar at Lompoc.

Sarah kept pushing into her future, looking for what would be a good fit for her professionally. Finally, in early 2007, Sarah knew that what she really wanted to do was open a bottle shop. Saraveza opened in October 2008.

The Name

Once she started to tell close friends that she was going to open a bottle shop, people started asking what she was going to call it. She did not know, but Sarah did know that sometime before her bottle shop opened, the name would come to her.

One day while stocking beer in the cooler at Pix Patisserie, Sarah said to herself, "Sarah get the cerveza." Then, in a moment of revelation, Sarah said out loud to herself—"Sarah-veza." Now she had a name for her bottle shop.

The Beer

Saraveza has ten taps. Nine of the ten taps are rotating and always have amazing seasonal craft beers on them. The tenth tap is always Hamms. Hey, if your uncle who doesn't like craft beer is visiting from the Midwest, you can take him to Saraveza and he can still get a beer to go with his brat.

At any one time, there will be about 250 different beers in stock that you can buy and take home with you. The staff at Saraveza work very diligently to have the bottle section at Saraveza be fresh, smart, seasonal and relevant.

The Food

The food at Saraveza is both an ode to the Midwest and off the charts! The chefs make their own sausage, and they have a house brat. You have to have a brat for when the Packers games are on. Even if you did not grow up near the UP, you will love the pasties. My favorite is the Nater, named for Sarah's brother Nathan. At least once in your life you have to get both the Meat & Cheese SchmorgasBoard and the Smoked Trout Board. The Pickled Deviled Eggs will blow your mind. So weird and good! Trust me on this. Order them. When they come to your table, you will notice that they are the wrong color. Pick one up and take bite anyway. You will discover that you are eating a pickled deviled egg—and that you love it.

Saraveza is one of the best beer bars in Portland and one of the best beer bars in the United States. You can quote me on that, but what you really need to do is go see for yourself.

· SEAN CAMPBELL ·

Do Something You Enjoy With Your Life

Sean was born in Suffern, New York, and his family moved around quite a bit when he was a child. Sean's dad worked for the State Department, and Sean spent his teenage years from ages twelve to eighteen in the Golders Green Neighborhood of London, England. Sean graduated high school from the American School of London.

The legal drinking age in England is eighteen, and Sean remembers being a senior in high school and going into a pub for lunch and having a ploughman's plate and a cask ale. When Sean moved to Virginia for his freshman year of college, he was very disappointed to discover that he could no longer buy beer.

During Sean's freshman year of college, he visited a friend attending the University of Oregon and fell in love with Oregon. Sean transferred to the U of O for his sophomore year and went on to graduate from there.

Following college, in 1996, Sean went to work at McMenamins Fulton Pub and Brewery. Sean works there to this day, and he is very proud of his affiliation with McMenamins. Sean says that Brian and Mike McMenamin take care of their employees and treat them really well. Sean put it this

Sean Campbell, owner of the Beermongers Bottle Shop and Beer Bar.

way: "I am just a bartender at McMenamins, and I have benefits, vacation, medical and dental insurance and a 401K."

In 2006, Sean began to think about opening a bottle shop, and on September 5, 2009, the BeerMongers opened. Today the BeerMongers is a much-loved Portland bottle shop and beer bar where people love hanging out. The Beermongers has the distinction of being one of John Foyston's favorite Portland beer bars.

The beers at the BeerMongers are arranged by style, and at any one time, there are about six hundred bottles on hand and fifty different styles.

Sean takes great delight in the fact that he has had employees go from working at the BeerMongers to becoming brewers (and cider makers) at the Commons, Burnside Brewing and Reverend Nat's Hard Cider. Sean sees this as one of the ways that he can serve the Portland beer community.

Special Beer Events

The BeerMongers regularly has tasting events, and it has a few wonderful annual events. Its anniversary party is September 5 each year, and every

year in October, it hosts an Orval Day (Orval being Sean's favorite beer). Christmas Eve Eve is each year on December 23, and that event features barrel-aged beers. April 20 each year is the date of the BeerMongers Smoky & Dank Beer Fest, which features both smoked beer and dank IPAs.

You Just Have to Go for It

Sean is incredibly glad that he opened BeerMongers, and his only regret is that he did not do it sooner. He regularly tells people thinking of making a career change that they just have to go for it. As Sean puts it, "It is so rewarding to do something you enjoy with your life."

· STEVE WOOLARD ·

"I Wanted Brewers in the Booth Telling Their Story"

Steve Woolard's beer journey started when he was nineteen years old. He drove a car ten thousand miles across Europe and fell in love with the beers he enjoyed there. The depth of flavors entranced him, and from then on, Steve was a beer fan. When Steve came back from Europe, he went to the University of Oregon, where he put Löwenbräu Dark on tap in his apartment and had a foosball table in his bedroom. Needless to say, Steve was popular in college.

Steve has been very involved in the Portland beer scene, and he has many very entertaining stories of the people he has come across. If you ever have the chance, buy Steve a beer and invest thirty minutes listening to a master storyteller.

In 1991, Steve joined the Oregon Brew Crew after reading something Fred Eckhardt had written about it in the *Oregonian*. Steve eventually served as the vice-president of the Oregon Brew Crew for two years. Steve worked at both Yamhill Brewing and Saxer Brewery in the mid-'90s. Steve first met Mike McMenamin in the early '80s at the West Hills Market out on SW Scholls Ferry Road.

Mike McMenamin owned the West Hills Market from 1977 to 1983. On Tuesday nights, Mike would do a wine tasting and open up ten bottles of

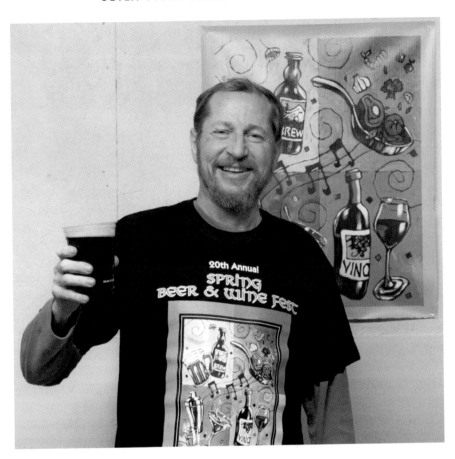

Steve Woolard, founder of the Portland Spring Beer and Wine Fest.

wine. Steve spent many Tuesday nights drinking wine with Mike. One fun note: in 1986, Mike bought that building back and renamed it the Raleigh Hills Pub, and it became the ninth McMenamins pub.

One of Steve's favorite beer adventures was being a part of the POETS society from about 1997 to 2000. The members of the POETS society would meet on Friday afternoons and smoke cigars, drink beer and talk about the Portland beer scene. This group included such Portland beer luminaries as Don Younger, Alan Sprints, John Harris, Fred Bowman, Steve Woolard, Stuart Ramsay and Jim Kennedy.

Portland Beer Stories

The Portland Spring Beer and Wine Fest

Steve loves the beer festivals that we have here in Portland, and he has been attending them for many years. In 1994, Steve started the Portland Spring Beer Fest. A few years later, the name was changed to the Portland Spring Beer and Wine Fest (PSBWF) as wineries got invited to the party as well.

Steve started this festival because he wanted there to be a Portland beer festival at which the brewers would be in the booths telling their stories directly to the public. Steve has always believed that brewers who tell their story will do much better, and to this day, he encourages the brewers who come to PSBWF to be in the booths and connecting with the people who stop by.

Food Carts and Beer—You Can't Get More Portland Than That

In addition to running the PSBWF, Steve is owner of the Carts on Foster Food Cart Pod on SE 52nd Avenue and SE Foster Road, and he owns the Pod Bar Food Cart at that pod. As you might well imagine, that particular cart serves beer. In fact, that cart usually has really good beer on tap. The Pod Bar also has indoor (read: heated) and outdoor seating. Rain or shine, Carts on Foster is a great place to enjoy a food cart meal and have a beer.

Steve is passionate about craft beer, and he is not a big fan of conglomerate beer. Steve believes that you should buy beer from a brewer that you could meet. I heartily second that. The beautiful thing about the Portland beer scene is that you really can meet the brewer who brewed your beer.

· TERI FAHRENDORF ·

She Belongs in the Craft Beer Hall of Fame

The Craft Beer Hall of Fame is a real thing, and I believe that that there are people in this book who should be inducted into it. Art Larrance, Rob Widmer and Kurt Widmer come to mind, as does Teri Fahrendorf. Teri's journey has inspired thousands of people. She calls Portland home, and I am honored to tell her story.

Teri was nine years old and living in Wauwatosa, Wisconsin, when she bought a booklet at a church rummage sale for a dime. Teri spent her whole week's allowance on that book. The booklet talked about how beer was made. Teri wanted to know. She grew up in a German American family in Wisconsin, and beer was part of everyday life.

This booklet talked about big equipment and machines, and Teri was disappointed to read that only factories could make beer and not people. That perspective changed when Teri went to college at the University of Wisconsin–Eau Claire.

Teri Fahrendorf.

Balloon Jug Wine

A college classmate of Teri's gave a presentation one day in class and taught everyone how to make jug wine. Put some grape juice in a jug. Add some baker's yeast and some sugar. Put a balloon over the mouth of the jug and wait. The balloon will swell up and then deflate. When it has deflated, you can drink it. Teri was fascinated by this. She did her own research and discovered that you could make both wine and beer at home. You did not need a factory.

In college, Teri kept going on and on about how someday she would go to Oregon. The stories of the pioneers who traveled the Oregon trail captivated her, and she was one for an adventure. Teri's college friends eventually gave her a sweatshirt that said "Oregon or Bust."

A Life-Changing Trip to Denver

In 1985, following college, Teri took a job in the Bay Area working in computers and technology. She also began homebrewing and joined a home brew club, the San Andreas Malts. In 1988, Teri took a trip to Denver and attended the American Homebrew Association's National Homebrewers Conference. In this year, this conference was held in conjunction with the Great American Beer Festival (GABF).

During these conferences, Teri met John Maier, saw Mellie Pullman on stage at the GABF receiving a medal and learned about Seibel. John Maier is the brewmaster at Rogue Ales now, but back in 1988, he was with Alaskan Brewing. As he and Teri talked, she discovered that before he became a brewer, he had worked in the aircraft industry. Teri thought that if he could leave his industry for brewing and survive financially, that she could leave her industry for brewing and survive financially. Mellie Pullman was the brewmaster at Wasatch Brew Pub & Brewery in Utah, and when Teri saw her on stage receiving a medal, she thought to herself, "If she can be a brewer, so can I." When Teri heard about Seibel, she learned that there was a place that would teach you how to brew beer professionally. That weekend, she decided to become a brewer.

Teri went home to the Bay Area and asked her employer for a three-month leave of absence so that she could go to Seibel, but that request was denied. Teri quit her job and signed up to attend to Seibel. She then read about the very first Oregon Brewer's Festival happening in Portland, and she drove up and attended before heading off to Seibel, where her classmates voted her class president. Teri was the first woman to ever be voted class president at Seibel.

Following Seibel, Teri interned at Sieben's River North Brewpub in Chicago before heading back to the Bay Area. Teri then became the brewmaster at Golden Gate Brewery, and then she became the brewmaster at Triple Rock Brewing. In 1990, Teri attend the third Oregon Brewers Festival here in Portland, and she saw a guy wearing a shirt that read, "Brewer Wanted, Eugene, Oregon." Teri saw that shirt and wondered if this was when she would finally get to live in Oregon.

Teri spoke to the guy with the T-shirt, and she was hired to be the brewmaster at Steelhead Brewery. Teri was there for seventeen years, from 1990 to 2007. During her time at Steelhead, she opened five different breweries and oversaw the brewing and brewers at all five of them.

If you are keeping score at home, you know that by now Teri had become the first woman to be voted class president at Seibel, the second female brewmaster ever in the United States and the first female brewmaster in both California and in Oregon. Terri is also one of the founding members of the Oregon Brewers Guild, and she served as its founding treasurer.

How Many of Us Are There?

In 2007, Teri left Steelhead and took a 139-day road trip visiting both family and seventy-one different breweries. You can read more about Teri's amazing road trip at roadbrewer.blogspot.com. When Teri got to Stone Brewing, she met Laura Ulrich, who was the first female brewer ever at Stone. Laura is still brewing at Stone to this day.

Laura was both surprised and delighted to hear that Teri was also a brewer. Laura told Teri that she had thought that she was the only female brewer out there. Teri began to hear this same thing from the other female brewers she encountered during her road trip. Teri also had the female brewers that she met asking her the same question: "How many of us are there?" Learning about and connecting with other female brewers was very encouraging and inspiring.

That road trip led Teri to start the Pink Boots Society, a growing organization that supports women who are professionals in the beer industry. Today there are over 1,700 members in the Pink Boot Society, and they have local and regional chapters across the United States and in seven other countries, including Belgium, France and Australia. Teri has done more for women in the beer industry than anyone else ever.

Today, Teri is working at Country Malt Group, a subsidiary of Great Western Malt. The way I want the Disney movie about Teri to end is with Teri owning her own brewery here in Portland. Given how talented she is, I will not be surprised if that happens someday.

Let me close this chapter the way it began: Teri Fahrendorf belongs in the Craft Beer Hall of Fame. I hope that the good people in Williamsport, Pennsylvania, are listening.

Beer Writer's Perspective
Tim Hohl

Tim Hohl is the host of First Edition with Tim & Terry *on KPAM Radio in Portland. His award-winning* Beer Geek *segment airs Thursday mornings at 7:40 a.m. He is an accomplished homebrewer and most recently the founder of Coin Toss Brewing Company in Oregon City, Oregon.*

Everybody remembers their first. When. Where. Who you were with. Mine was a Grant's. Fall 1988. Sitting at the bar at Jacobi's Café in Walla Walla with my friend Gene.

Mind you, I'd enjoyed beer before. I enjoyed the social life in my college fraternity. Cheap and yellow, it served its purpose at the time. We'd splurge once in a while and drink Henry Weinhard's Private Reserve. It made us feel like we were drinking something special. To this day, it remains one of my favorite easy drinkers.

I'd also just returned to the States from a year of study abroad in Great Britain, where I'd discovered the joy of cask ale and developed an appreciation for subtle flavors, aroma and cellar temperatures.

But that day at the bar in Walla Walla was something completely new. Floral. Bitter. Beautiful.

Months later, after graduating from college and moving back to Portland, a friend and I bought a six-pack of something called "Blue Heron Pale Ale" from Bridgeport Brewing, not really know what it was. But it was right there on the grocery store shelf next to the Henry's, so it had to be good, right? The answer was yes. Another magical craft beer moment.

These two experiences led to a crusade of sorts. Discovering new beers, new breweries and the people behind them became a borderline obsession.

I've been to hundreds of breweries around the Northwest and across the country. The longer the list grows, the prouder I am to be from Portland, Oregon. Beervana, USA.

Whether it's Montana or Missouri, you become an instant celebrity when you get asked, "Where are you from?" and the reply is Portland.

With one word, you go from just another guy sitting at the bar to a craft beer VIP. And it always leads to a memorable experience. Like the time we stopped at an upscale steakhouse and brewery in my boyhood hometown of Birmingham, Michigan. Not the usual stomping grounds for a group of beer geeks from the Northwest. As we peppered the bartender with questions

124

about ABV and IBUs and tossed around a few geographical terms, he looked at us and asked, "Are you all from Oregon?" Next thing we knew, we were standing in the brewery, drinking samples directly from the brite tanks and talking to the head brewer like he was our new best friend.

If there's one thing I love more than Portland beer, it's the people behind it. As the industry has grown, so has my admiration for those who make it happen, from the brewers to the bar owners to the sales people to the festival organizers and everyone in between.

Sure, it's competitive, just like any other business. But there's an overriding sense of camaraderie and collaboration that never ceases to amaze me. The industry thrives on it. That mentality goes a long way toward explaining why so many Portland craft breweries can not only exist but also grow, expand and prosper.

I've heard countless stories, for instance, about a brewer running short on ingredients in the middle of a brew session. But a few phone calls and text messages later, here comes a competitor to the rescue with a batch of hops or yeast.

In my years of covering the Portland craft beer industry on the radio, with very few exceptions, no one has said no to a request for an interview. More often than not, the in-studio interview at the radio station leads to an invitation for a pint or a tour and a new friendship.

To quote Don Younger's most famous line: "It's about the beer. It's not about the beer." It's about the beer, the creativity, the passion and the people. So many stories to tell!

Beer Writer's Perspective
Kris McDowell

Kris McDowell is a longtime craft beer lover, writer and marketing director for Brewvana Brewery Tours. She and her husband started their beer blog while living in Minnesota, and there she was a contributor to the beer website MNBeer.com. Immersed in and enjoying the craft beer culture there, the decision of where to relocate from the frozen tundra was heavily influenced by the beery-ness of the top contenders: Denver, Portland and Seattle. Setting down stakes without knowing a soul in town was made easier by immediately seeking out Portland's craft beer scene. Kris has continued her blog, Beer Musings, at www.bitteredunits.blogspot.com, been a contributor to the Taplister blog and writes for the beeriodical Oregon Beer Growler.

Portland hasn't acquired the nickname "Beervana" for no good reason. In fact, it's been hard earned by the breweries that have been around since before the term "craft brewery" was commonplace, as well as the ones that have followed in their footsteps. Those breweries don't just produce great beer. They are also owned by and employ great people, the kind of people whose enthusiasm about what they're doing and what they're producing is evident even during a brief conversation.

Accessibility is one of the things that make the Portland beer scene so special to me, and I'm not talking about just the accessibility to brewers, as I've found that brewers across the country are accessible and welcome the opportunity to talk about their craft. What I'm talking about is accessibility to the product. Here you don't have to seek out a brewery, brewpub or craft beer bar (although I'd highly recommend it) to find the good stuff on tap. Nearly every place serving beer—from the local dive bar down the street, to the fancy restaurant you could blow an entire paycheck at for a single meal, to the sports bar you visit on Sundays with enough TVs so you can keep tabs on your entire fantasy football roster—has at least one craft beer on tap.

Portland is an ideal location for craft beer due to its geographic location that allows brewers easy access to some of the largest hop-producing farms as well as a great water supply, something that no beer can be made without. Beyond that, Portland laws are generally favorable to those in the business of beer, something that has allowed it to flourish. As a transplant from Minnesota, a place where Sunday sales of packaged beer (cans, bottles and growlers) is still illegal and more than one brewery has

taken its expansion across state lines into Wisconsin where their laws are more brewery-favorable, I don't take for granted the freedoms that the lawmakers here have given the industry.

There are so many breweries in Portland that I love to go to but I have to say that the places I recommend to people who are new to town or just visiting are beer bars. Whether one only has a few hours to spend in Portland and needs to get the most bang for their beer time here or one has the luxury to fully immerse themselves in all there is to be had, the following three places can serve up whatever you desire.

The BeerMongers, located in inner Southeast Portland, has been my Cheers since shortly after I came to Portland. It is more than just the sum of its parts—eight taps, hundreds of bottles and a cozy setting. There is a feeling of community that the regulars will happily extend to anyone bellied up to the bar next to them and a welcoming hello from the beertender on duty when you walk in the door. An added bonus, at least in my eyes, is that they don't serve food and therefore invite you to bring in whatever suits your fancy. Maybe that's a burrito from across the street to fill an achingly empty belly, maybe tonight's the night to have a little fun with your beer and you've brought in a selection of cheeses to try your hand at pairing it with or maybe you forgot all about food until you sat down and you'll be happy ordering a pizza to have delivered.

A bit farther out, but still in Southeast Portland, is Roscoe's. Located in the quickly growing Montavilla neighborhood, from the outside, one would probably peg it as a dive bar and perhaps move on without giving it a try. That would be an unfortunate move, as contained within its walls is a tap list that will rival anyone with a fancy, digital beer menu and spiffy exterior. Roscoe's menu is humbly listed on a handwritten chalkboard, one that is bulging at the seams with special beers, even at times when it isn't hosting a "summit," their version of a tap take over/mini beer festival. The Cajun-inspired food served goes great with beer, but the even cooler thing is that you can order off the menu of the adjacent sushi restaurant from your table. That's right, the same server who brings your beer will ferry your order to their kitchen and return with sushi.

My third recommendation is the only one that sits across the river, a convenient block south of one of the main east–west roads, Burnside. Bailey's Taproom is a place that I was not immediately enamored with, in part because early on, its wall-mounted beer menu was difficult to read and often times it is pretty packed (and I don't like waiting in line for my beer). Bailey's Taproom has since replaced the original beer menu with a really

cool one that shows the amount left in each keg, and I've gone back enough to know that 1) it constantly has an amazing beer selection and 2) the key to my happiness in visiting is going at off-peak times when I can find a seat and not have to worry about getting in line for my next beer when my current one is still half full.

TEN MORE PORTLAND BREWER STORIES

FROM BARREL-AGED TO SERVED WITH A SLICE OF LEMON

• HAIR OF THE DOG BREWING CO. •

"I Thought That It Would Be Easy"

When people who knew the Portland beer scene would find out that I was writing this book, they would tell me that I *had* to include two Portland brewers, and Alan Sprints was one of those two. Some people say that Alan brews some of the best beer in America. I will say this: for my money, if you were to visit just *one* beer place here in Portland, I would make Hair of the Dog that one stop. Here is Alan's story.

From Chef to Brewer

In 1988, Alan left both Southern California and the aerospace industry and moved to Portland to attend Western Culinary Institute. Alan graduated a year later and spent the next two years working in Portland as a chef. Alan worked in fine dining and in industrial kitchens, and his culinary background is one of the main reasons that the food at the Hair of the Dog is so fantastic. When you visit, make sure to have both a beer *and* a meal.

Also in 1988, Alan attended the very first Oregon Brewers Festival. Shortly after that, he began homebrewing and joined the Oregon Brew

Alan Sprints of Hair of the Dog.

Crew, of which he eventually became president. In 1991, Alan went to work at Widmer as a brewer, though his first job at Widmer was filling kegs. In 1993, Alan left Widmer to open a brewery of his own.

The Name: Perfect for Hangovers

In drinking circles, the "Hair of the Dog" is the cocktail that you want when you have a hangover. Some people say that you should have a Bloody Mary, while others suggest a beverage involving gin, rum or brandy. The variations are endless. Alan knew that he was going to be making strong ale, and the thought of naming his brewery the Hair of the Dog was delightful to him.

Adam: The First Hair of the Dog Beer

Two beer writers, Michael Jackson and Fred Eckhardt, had written about an extinct beer from Dortmund, Germany, called Adam, and Alan had heard

about it from both of these individuals. Michael and Fred had learned about Adam from London-based author John Bickerdyke. In 1889, he published *The Curiosities of Ale & Beer: An Entertaining History*. In that book, John devotes a couple paragraphs to this beer, which was very strong and barrel aged for ten years. My copy has this text on page 180.

In 1994, Alan started brewing beer at his first location on Holgate Boulevard and 23rd Avenue, and he decided that he would brew this extinct beer. There was no recipe for Adam, so the Adam you can get today at the Hair of the Dog is Alan's take on this extinct beer style. Alan was careful to use ingredients that a brewer in Dortmund, Germany, in the mid-1800s would have had access to.

Alan was also inspired by the Thomas Hardy beer brewed by the Eldridge Pope Brewery from 1968 through 1999. This beer was brewed in such a way that you could it enjoy it when it was twenty-five years old. When Alan opened Hair of the Dog, he set out to brew beer that got better with age.

For the first year and half, the only beer that Alan brewed at the Hair of the Dog was Adam. He would bottle eighty cases in a batch, and each batch was numbered. Some lucky people still have bottles of the first batch of Adam in their beer collection.

Alan then began to add barrel-aged beer to his repertoire, and he was the first brewer in the Northwest to do so. His first batch of barrel-aged beer, called Adam from the Wood, was barrel aged for eight years. Now Adam from the Wood is barrel aged for three years. Cherry Adam, one of my all-time favorite beers, is barrel aged for a year and half.

Alan's barrel-aged beer is amazing. In 2013, he sold twelve bottles of the barrel-aged beer known as Dave for $2,000 each. Back then, you could get a bottle of Dave "to go" for $2,000 or $1,500 if you drank it in the tasting room. Today, you can only purchase a bottle to enjoy in the tasting room. You pay your $1,500, and the beer is opened and brought to your table.

More Than Twelve Years

From the very start, Alan received critical acclaim, but financial success took much longer. Alan would go years at time without a paycheck. You read that correctly—years. Alan stayed the course because he believed in what he was doing, and so did his loving wife, Eliana. It was not until 2006 that Alan began to get regular paychecks and started to see to see the financial success that he has worked so hard for.

In 2010, Hair of the Dog moved to its current location on SE Water Avenue and SE Yamhill Street and added both a kitchen and a tasting room/pub. For the first year that he was open at the location, Alan was both the brewer and the chef. He would brew in the day and cook in the evening.

Alan, like most people who see their startup succeed, put in lots of effort and paid quite a price for the success that he now enjoys. One of the biggest challenges that he had his year first running Hair of the Dog was that he thought that it would be easy. He had no idea how much time and effort it would take to get to where he is now. Needless to say, Alan is very grateful that he stuck with it, as are many beer fans across the United States.

• KELLS IRISH PUB AND BREWERY •

First a Pub and Then, Twenty-Nine Years Later, a Brewery

Kells has become a Portland institution. It has a pub in downtown Portland on SW 2nd Avenue and a brewery with a pub on NW 21st Avenue. In my opinion, to adequately tell the Kells story, you have to talk about four very special people: Gerard and Lucille McAleese, Garrett McAleese and Dave Fleming.

Kells Irish Pub on SW 2nd Avenue in Portland.

TEN MORE PORTLAND BREWER STORIES

Born in Belfast

Gerard was born in Belfast, Ireland, and his beer journey started as a young man enjoying pints at the Crown Bar in Belfast, Johnny Joe's in Cushendall and Mariners in Glenariff.

In 1980, Gerard left Ireland and immigrated to Seattle, Washington. When he arrived in the United States, Gerard ended up playing semipro football (soccer) in Seattle and San Francisco. After matches, he would visit Irish pubs. Many of them were not that clean, and quite a number of them were kitschy; as Gerard put it, "They had cardboard shamrocks on the walls."

Those pub experiences led Gerard to open Kells Seattle location in 1983. He wanted an authentic, clean Irish pub in which to have a pint, and he figured that many other people would as well. Gerard is the quintessential hardworking entrepreneur who always seems to find a way through grit and effort to accomplish what he sets out to do.

The Name

Gerard wanted a name for his pub that would let Irish folk know that his pub was an authentic Irish pub. He wisely choose Kells. If you grew up in Ireland, you knew about the Book of Kells. Some say that the Book of Kells is Ireland's finest national treasure. The Book of Kells is a very old Irish document containing the four Gospels of the New Testament. The Book of Kells got its name from the from the Abbey of Kells in Kells, County Meath, Ireland. The Book of Kells is now on permanent display at Trinity College Library in Dublin.

A Chance Meeting in the Los Angeles International Airport

In 1986, Gerard was walking through LAX when he spotted a woman carrying her luggage. Gerard stopped and said, "Can I help you with your luggage?" Lucille was inclined to say no, but then she took a second look and decided that perhaps this man was worth the risk. Lucille said yes.

When they parted ways a few minutes later, Gerard asked for her phone number. Lucille said, "I don't give out my number, but I am willing to take

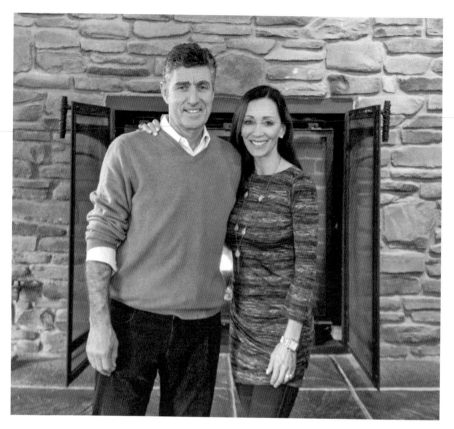

Gerard and Lucille McAleese of Kells Irish Pub.

yours, and I might even give you a call sometime." Lucille did call, and in 1987, they were married.

In January 1990, Gerard and Lucille moved to Portland, Oregon. They felt like it was a great place to raise a family. In June 1990, Gerard opened Kells Pub in Portland. They have never regretted their decision to move to Portland. They love both the city and the close-knit craft beer community that they have watched develop over the past twenty-five years.

Gerard speaks very highly of Rob and Kurt Widmer. Rob and Kurt are friends and have provided Gerard with excellent insight along the way. Gerard has found their counsel to be particularly helpful once Kells Brewery opened in Portland on August 15, 2012.

That brings us to Gerard and Lucille's son Garrett. Garrett's beer story began in an Irish pub. When Garrett was a young man, his dad took him

and his younger brother to Ireland, where he had his first pint: Guinness, of course, at the aforementioned Mariners in Glenariff.

Garrett traces his love of brewing to the science classes he took at Da Vinci Middle School in Portland. For three years, Garrett had a terrific science teacher, Dan Evans. Dan sparked in Garrett a love for learning and figuring out how something works and is put together.

Garrett attended the University of Oregon–Eugene, and while there, he keenly followed the progress of Ninkasi Brewing. One of his favorite beers in college was Ninkasi Tricerahops. A step in Garrett's college journey included studying abroad in Rosario, Argentina. While there, Garrett met two guys from San Diego who were in the process of opening Fenicia Brewing Company in Rosario.

Garret got to watch the tanks being installed and saw the brewery being put together before his very eyes. He felt the same excitement that he had felt where he was in Mr. Evans's science class. Once they started brewing at Fenicia, Garrett brewed with them, and he fell in love with brewing.

When he got back to the United States, he began to homebrew, and he told his dad that Kells needed to open a brewery. Eventually his dad agreed, and they found a space and started construction.

I have to say that I am so impressed with Garrett. For someone under thirty, he showed incredible maturity, and he is the kind of young man that I want my teenage sons to be around. The night I got home from interviewing Garrett, I went and told my son Zac, who is attending college here in Portland, that I hope that while he is in college he gets a summer job working for Garrett. He would learn a tremendous amount.

As I see it, Garrett is the founder of Kells Brewery. It was his vision and his leadership that resulted in that brewery being in existence today. Garrett is also very humble. He was quick to give high praise to Kells brewmaster Dave Fleming for creating the Kells Irish Stout and very reluctant to admit that he created the recipes for the Irish Red Ale, Irish Lager and Irish Pale Ale. Those beers are very good, and that is quite an accomplishment. Garrett is an incredible young man.

It Started with Paulaner Salvator, the Original Dark Doppel Bock

Dave Fleming's beer journey started when he was in high school in New England. His dad was a veracious reader, and one day Dave's dad was

reading Howard Hillman's *The Gourmet Guide to Beer: The Most Comprehensive Guide to All the Beer available in the U.S.A.! Authoritative Ratings of 500 Imported and Domestic Beers.* Dave saw this book, and he was shocked that there were five hundred different beers in the world.

Dave went through the book, picked out all of the five-star beers and did some research. It turns out that the only five-star beer from the book that their local package store had in stock was Paulaner Salvator. Dave had a friend buy him that beer, and he tried it. He was blown away. Dave says that his love of beer started right then and there. Shortly after that, Dave began homebrewing.

Following college, Dave came to Portland in 1991 to attend gradate school at Portland State University. Dave got asked to play second base on the Bridgeport softball team, and two weeks later, he was working at Bridgeport, "slinging pizzas and beer." In 1994, Dave got offered a management position at the Lucky Lab Pub on Hawthorne. In January 1996, Dave made the move into brewing when started working in the Hawthorne Lucky Lab Brewpub. Dave stayed at the Hawthorne Lucky Lab until 2002.

From 2002 through 2012, Dave worked at a number of breweries, including Silver Moon in Bend, the Old St. Francis in Bend, Three Creeks in Sisters and Lompoc here in Portland. During this ten-year run, he helped

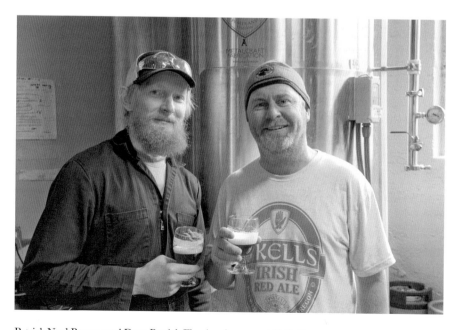

Patrick Neal Barnes and Dave Patrick Fleming, brewers at Kells Brewery.

four different breweries get installed. Dave loves solving the challenges that come with installing a brewery.

In 2012, Dave was living four blocks from the brewery that Kells was opening on NW 21st Avenue. One thing led to another, and in July 2012, Dave become the founding brewmaster of Kells Brewery. The first order of business was getting the brewery up and running and getting the red ale, the lager and the IPA going. Once the brewery was squared away, Dave tackled the challenge of making an Irish stout.

Nitrogenation: The Biggest Challenge

Kells is an Irish pub, and it wanted to have its own Irish stout. It took Dave months to get this beer perfected. First, he worked on the recipe. He made sure that his Northwest take on an Irish stout had traditional Irish stout roots by using roasted barley, flake barley and black barley—all common ingredients in an Irish stout.

Dave then began a months-long journey working on creating his own process for nitrogenizing his Irish stout. Most beers are carbonated with carbon dioxide. Nitrogenation is the process of carbonating a beer with nitrogen. It is not easy to do. When you pour a stout that has been properly carbonated with nitrogen, you get a beautiful cascading effect, which produces a dark brew with a fluffily white head that has a very creamy mouth feel.

Dave did eventually nail it. He figured out a way to nitrogenate this beer "in line," and the Kells Irish Stout is a thing of beauty. It looks fantastic, and it tastes even better. Honestly, I don't think that many brewers have the skill to pull off what Dave did when he created the Kells Irish Stout. When you visit Kells, make sure have to a pint and see for your self what a great beer it is!

· LAURELWOOD PUBLIC HOUSE AND BREWERY ·

Because of a Call to Kurt Widmer

Mike De Kalb opened Laurelwood Public House and Brewery in March 2001. It all came about because of a phone call to Kurt Widmer. Prior to opening Laurelwood, Mike worked for a concessions company overseeing fourteen restaurants at the Portland International Airport.

Mike De Kalb, founder of Laurelwood Public House and Brewery.

One of those fourteen restaurants included the Widmer Pub at the airport. It was through this job that Mike got to know Rob and Kurt Widmer. Mike reached a point in his journey where he began to look for a location to open a restaurant of his own.

He finally found the perfect spot on NE 40th Avenue and NE Sandy Avenue. As he toured the space with a commercial realtor, Mike discovered that there was brewery inside. Mike knew the restaurant business, and he was not sure what to do with this brewery.

Mike picked up the phone and called his friend Kurt Widmer and said, "I found the perfect place for my restaurant, and there is a brewery inside of it. What do I with this brewery?" Kurt said, "Open a brewery and hire Christian Ettinger to be your Brewmaster." Mike is very glad that he listened to Kurt, and so are all the fans of Laurelwood.

The Name

Laurelwood is a combination of two Portland neighborhoods near and dear to Mike's heart. Mike lived in the Laurelhurst neighborhood, and the first brewpub location he opened was in the Hollywood neighborhood. Put the two names together, and you have Laurelwood!

Workhouse IPA is far and away the most popular of the Laurelwood beers. The Free Range Red and the Tree Hugger Porter are also top sellers. Initially, the Tree Hugger Porter was called Laurelwood Organic Porter. Shortly after this beer was introduced, its name was changed. Mike had a server working for him from Georgia named Shannon, who was convinced that this beer needed an actual name. One day, in her Southern drawl, Shannon declared, "Y'all are tree huggers here in Oregon. You should call it that." The name stuck.

Shane Watterson: Following in Big Footsteps

Shane is the fourth brewmaster at Laurelwood. Christian Ettinger, the founder of Hopworks Urban Brewery, was the first person to hold that title at Laurelwood. Chad Kennedy, founding Brewmaster at Worthy Brewing, was the second, and Vasilos "Vasili" Gletos was the third. In the fall of 2014, Vasili took a position at Hill Farmstead Brewing in his home state of Vermont. Christian, Chad and Vasili are all very respected brewmasters.

Thankfully, Shane's background prepared him very well to follow in Christian and Vasili's footsteps. Shane is a seventh-generation Oregonian, and following college, he began homebrewing. About the same time, Shane also joined the Oregon Brew Crew. Coincidently, he followed Vasili as the Oregon Brew Crew education chair. Shane shared with me that his time with the Oregon Brew Crew was very helpful to his professional brewing career.

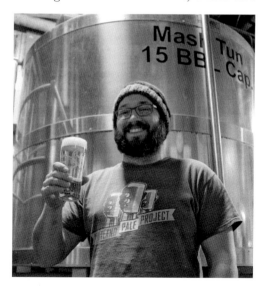

Shane started homebrewing because of the example of his dad and brother, and he is very grateful that their hobby led to him having a career that he loves. One interesting note: Shane first started brewing with two friends, including a friend who, years later, became his girlfriend and wife. I love

Shane Watterson, brewmaster at Laurelwood Public House and Brewery.

Brewers' gloves.

how the universe works. You meet someone, you become friends and, years later, you up end together.

The Love of Brewing

Shane's first pro brewing job was at Deschutes, where he eventually became an assistant brewer. Along the way, Shane went through the Beer Judge Certification Program and attended the American Brewer's Guild Intensive Brewing Science & Engineering Program. One of the biggest challenges that Shane had when he first started brewing professionally was getting used to how hard brewers work and the long hours they often put in.

Shane is a brewer today because he loves brewing, and that is exactly who you want brewing your craft beer. I have no doubt that Laurelwood is in good hands with Shane at the helm of the brewery, and I look forward to enjoying the beers that he will introduce to the already stellar lineup.

· LOMPOC BREWING ·

It Happened Over a Round of Golf

Jerry Fechter grew up in Columbus, Ohio, and following college, he moved to Portland primarily because he had a brother who lived here. Jerry worked a couple different jobs, and in 1991, he started working for Bob Rice and Peter Goforth, owners of Goforth and Rice, a Portland company that specializes in restaurants and cafés. In 1993, Goforth and Rice bough the Old Lompoc on NW 23rd Avenue in North Portland, which is also known as the Fifth Quadrant. The Old Lompoc had been named after the Old Lompoc House, which figured prominently in W.C. Fields's 1941 film *The Bank Dick.*

Peter and Bob began to talk about adding a small brewery to that space. Jerry heard about this idea and volunteered to run that brewery. In 1996, Jerry became the brewmaster of the Old Lompoc Brewery located at the Old Lompoc.

In 1999, during a round of golf, Jerry approached Peter and Bob about buying both the tavern and the brewery from them. Before the round was

Jerry Fechter of Lompoc Brewing.

over, they had agreed to sell them to Jerry and even named their price. Jerry began to look for an investor to go in with him on this project.

When his first potential partners fell through, Jerry mentioned to a friend named Greg who worked at Steinbarts and Belmont Station that he was back to square one needing to find a partner. A few hours later, Portland beer legend and owner of the Belmont Station Don Younger called Jerry and said in his unmistakable voice, "Jerry, this is Don Younger. We have met a few times before, and I hear that you might be looking for a partner to invest in a brewery."

Jerry and Don met a few times, and Don ended up investing in what became the New Old Lompoc in May 2000. The New Old Lompoc was a brewpub, both a tavern and a brewery. Don Younger passed away in 2011, and a portrait of him painted by none other than John Foyston hangs in the Lompoc Sidebar in his honor.

In 2012, all brewery production for Lompoc Brewing was shifted over to its Fifth Quadrant Brewery on N Williams Avenue. The Fifth Quadrant brewery is owned by Lompoc Brewing and does all the brewing for all the Lompoc locations, as well as producing all Lompoc bottled and draft beer.

Today Lompoc Brewing has five Portland locations. Thankfully, the New Old Lompoc was torn down, and the Lompoc Tavern opened in 2013 in its place. I always had a hard time keeping track of all of the "old" and "new" Lompocs.

The company also has the Hedge House on Division Street, Oaks Bottom Public House on SE Bybee Boulevard, Fifth Quadrant on N Williams Avenue (the Fifth Quadrant Brewery shares space with this pub) and the Sidebar, also on N Williams Avenue.

Why The Fifth Quadrant?
Time for a Portland Geography Lesson

As I mentioned in the Burnside Brewing chapter, Portland is divided into five quadrants. It is split east and west by the Willamette River and north and south by Burnside. Hence, we have Northeast Portland, Southeast Portland, Southwest Portland and Northwest Portland.

The Willamette River curves a bit to the west just north of downtown Portland and creates the "fifth quadrant," known as North Portland. If you want to know what quadrant you are in, just look at whether you are on or near a street that begins with a NE, SE, SW, NW or N.

The Secret Origin of C-Note Imperial Pale Ale and C-Sons Greetings

Lompoc's C-Note Imperial Pale Ale is one of its best-selling beers. A number of years ago, it came time to brew a beer for a special event, and brewer Dave Fleming suggested that they brew a beer using all of the C hops—that is, all of the hops that started with the letter C. The beer tasted great, but they were having a hard time coming up with a name for it.

Jerry was discussing this naming dilemma with his friend Randy Block. As soon as Jerry mentioned that this beer had an IBU of 100, Randy immediately said, "Call it C-Note." Bam. Beer named.

The original C-Note had an 8 percent ABV. Jerry wanted more of a session IPA, so they modified it to have a 6.9 percent ABV. That is the C-Note that is known and loved throughout Portland today. You can still get that 8 percent Imperial IPA each year during the holidays. It is called C-Sons Greetings. Both of these beers are made with seven hops: Crystal, Cluster, Cascade, Chinook, Centennial, Columbus and Challenger. And now you know.

· MCMENAMINS ·

It's Been a Long Strange Trip

McMenamins currently has sixty-five pubs and twenty-four breweries across the Northwest. In the Portland metro area alone, it has forty-three pubs and eleven breweries. That's just the beginning—it also has movie theaters, music venues, hotels, spas, two distilleries and a winery. It is a wonderful empire that all started in 1983 with a pub on the corner of Hawthorne and Seventeenth.

If you live in the Portland area, chances are that there is a McMenamins near you. I love McMenamins! You can always get a cold beer and a good meal, and each one of its locations has décor that is unique to it. Once you have been to five or six different McMenamins pubs, you start to see that even though they all look different, each of the locations has a distinctly "McMenamins" feel. When you are in a McMenamins, you know that you are in a McMenamins.

McMenamins Barley Mill Pub.

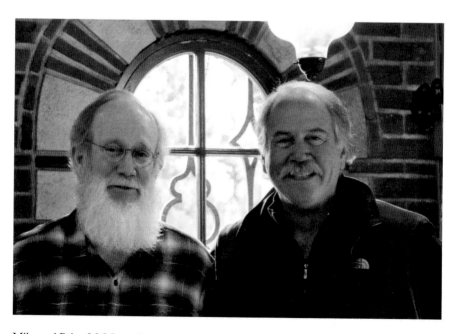

Mike and Brian McMenamin.

Ten More Portland Brewer Stories

Portland Beer Legends

Brian and Mike McMenamin are true beer legends. They are also great guys who have a wonderful legacy.

Along with the Widmer brothers, Art Larrance, Dick and Nancy Ponzi, Fred Bowman, Jim Goodwin and Carl Ockert, Brian and Mike McMenamin were the pioneers who got Oregon law changed so that brewpubs were legal. That story is well told in Pete Dunlop's excellent book *Portland Beer: Crafting the Road to Beervana*.

In 1985, Brian and Mike McMenamin opened the very first brewpub in the state of Oregon, the Hillsdale Brewery and Public House located in Southwest Portland.

McMenamins was the very first modern-day (post-Prohibition) brewery in the United States to make a fruit beer. The second batch ever at Hillsdale was a blackberry and marion berry fruit beer brewed on October 29, 1985. Ruby Ale, a wonderful raspberry beer that McMenamins started brewing in 1986, is one of its best-selling beers.

Many, many brewers have gotten their start at a McMenamins brewery. In this book alone, John Harris, founder of Ecliptic Brewing; Jason McAdam, co-founder of Burnside Brewing; and Jack Harris, co-founder of Fort George, all began their professional brewing careers at a McMenamins brewery.

Which Portland-Area McMenamins Should You Visit?

As I mentioned, there are forty-three McMenamins locations in the Portland area. If you were to go to just one of them, I would go to the Edgefield out in Troutdale. It's really cool. Just spend an hour walking around, and you will see what I mean. It's also a great place to see a concert.

If you are at Edgefield in the winter, have a beer by the fireplace in the Little Red Shed. If it is summer or early fall, drive up highway 84 to exit 40 some morning and take the 1.8-mile round-trip hike to Wahclella Falls, then head back down 84 to Edgefield and have a beer and a meal that afternoon at the Loading Dock Grill. They have wonderful outside seating.

If you are a fan of beer history, go have a pint at the aforementioned Hillsdale Brewery and Public House. If you are a fan of the Grateful Dead, go to the Barley Mill Pub on SE Hawthorne Boulevard and SE 17th Avenue here in Portland. This pub is chockfull of Grateful Dead memorabilia, and the music you hear playing in the background is—you guessed it—the

McMenamins Barley Mill Pub is the perfect place for Grateful Dead fans to have a beer.

Grateful Dead. It case you didn't know it, Brian and Mike McMenamin are huge Grateful Dead fans.

I myself am a huge fan of McMenamins, and all I ask is that they just keep truckin' on.

Beer Writer's Perspective
Christopher Pierce

Chris is the founder of PortlandBeer.com and @PDXBottleShare.

In Portland, craft beer is simply "beer." For example, in Buffalo, New York, you don't order Buffalo wings, you simply order wings. Here in Portland, you expect that the beers on the menu of any given pub, restaurant or movie theater are going to be fresh local delicious craft beers, aka "beer." The approach of the craft beverage industry in the city of Portland as a whole is one of dedication to old world craftsmanship. Both traditional beer styles and a whimsical interpretation of traditional beer styles are brewed here to satisfy even the most complex palates and the latest trends in nutritional restrictions.

The enjoyment of beer in Portland is facilitated in the daily activities of everyday life. Portland's Trimet transit system makes responsible drinking easy and affordable. There always seems to be a beer festival or event going on. Meetings and gatherings are just as likely to happen in a brewpub as a coffee shop. Portland grocery stores have refrigerated beer selections which rival most other cities' best bottle shops, not forgetting to mention the ability to have a pint of beer in the store and fill your growlers before, during or after shopping for your weekly groceries. And then there are the Portland bottle shops and taprooms. Some bottle shops have easily over one thousand selections of cans and bottles, and due to the sheer volume of beer that they pour, the beers on tap have rarely been on tap for more than a day or two, guaranteeing freshness. The bottle shops traditionally receive limited selections of rare and seasonal beers first before anyone else in town.

If you're tech savvy—and odds are that you are—you're in luck. Many of the taprooms and growler fill stations use a computerized digital beverage dashboard with social media integration so you can see when a beer was tapped, which beer it replaced, how much it costs for a particular sized pour, how much is left in the keg, what the percent alcohol it is or ABV (alcohol by volume), how bitter it may taste or IBUs (international bittering units) and even a current feed of social media posts and pictures from patrons in the establishment who may be sitting or standing right next to you. The tech communities across the United States tend to love their beer—or craft beer, to some—and Portland is no exception.

I get bored easily, so I'm always trying new things. That is one of the reasons that I founded @PDXbottleshare. Portland was in need of a

traveling monthly event that people could open and share their more rare, often cellared beers or beers that they brought back to Portland while traveling elsewhere. The response has been overwhelming. You know that special beer that you hid out in the garage or in the back of the veggie crisper drawer hoping that your drunk uncle wouldn't find it after polishing off the thin, fizzy, yellow swill that is passed off as an American lager but is actually brewed by a multinational Brazilian/Belgian mega corporation? The one that was aged in bourbon barrels for twenty-four months, with cocoa nibs and dark cherries. Yeah, that one. The one with the cork and cage, and the gold foil, that was hand numbered and signed by the brewer and assistant brewers. The one with a best after date and no best by date. The one that cost as much as a decent bottle of Pinot noir. That is the bottle that you bring to share at @PDXbottleshare and treasure with thirty to one hundred like-minded individuals just like yourself who will bring rare and adventurous beers just like it, only different. You'll find us at a new brewery, bottle shop, bar or back yard each month. Come join us.

When I thought about three places in Portland to make it a point to go for a fellow beer lover, the answer was long and winded and there were a lot more than three must-see locations. However, when I filtered the list through my most common needs, the answer immediately popped into my mind based on several criteria. They should be family friendly, brew and serve their own unique beers, have delicious food and ideally be dog friendly with optional outdoor seating. Base Camp Brewing and Breakside Brewery satisfy all of these requirements nicely. The third choice, Hair of the Dog, while it is not dog friendly for patrons in a traditional sense and only offers seasonal outdoor seating, is my number one place to visit in Portland for anyone who loves beer. Owner and brewer Alan Sprints does more to raise money for Guide Dogs for the Blind than anyone I know, with his sales of Dave, a 29 percent ABV barleywine brewed in 1994 (currently selling for $1,500 per bottle). My favorite time to go to Hair of the Dog is for lunch. You'll probably see Wendy, Alan's sister, tending bar. Look at the dry erase board behind the bar to see which beer is on tap "From the Wood." Get a taster flight. Order the beef brisket, the duck confit salad and the grilled Brussels sprouts. Hair of the Dog will open your eyes to a new world of beer appreciation.

· OLD TOWN BREWING ·

Keep an Eye on This Brewery

Old Town Brewing opened at the end of 2011. You may not have heard of this brewery yet, but I am pretty sure that over the next few years, you will hear a lot more. It has a terrific story involving great brewers and really good pizza.

Two Birthday Parties

When Adam Milne was nine years old, he had a birthday party at Old Town Pizza in Eugene, Oregon. Old Town Pizza opened in 1974 and grew from the flagship store in Old Town neighborhood of Portland to a number of locations across Oregon.

Flash forward twenty-one years: Adam was now living in Portland and working in marketing for a major shoe and apparel company. Adam discovered that the original Old Town location on NW Davis Street was still open. Over time, all of the other locations had closed, including the one in Eugene that Adam had enjoyed so much growing up.

Adam had his thirtieth birthday party at Old Town Pizza and had a great time hanging out with friends at this iconic Portland pizza place. Old Town occupied a warm place in Adam's childhood and heart.

A few years later, Adam was looking to make a career change, and he saw in the *Oregonian* that Old Town Pizza was sale. He had seen other iconic restaurants get sold, and he knew that sometimes the transitions did not go well. New owners would occasionally make significant changes that ended up ruining beloved institutions. Buying an established restaurant can be very tricky.

Adam did not want Old Town Pizza to suffer that fate, and he was ready to make a change himself, so he bought Old Town Pizza. He only made two changes: Old Town started delivering pizza by bicycle, and he made sure the kitchen staff was able to buy the best ingredients possible.

Adam pulled it off quite successfully, and Old Town began thriving once more. In 2008, Old Town Pizza opened a second location on Martin Luther King Boulevard. As early as 2005, Adam had begun thinking about opening a brewery. He loved the Portland beer scene, and he wanted to be a part of it.

Finally, in 2012, Old Town Brewery opened. The brewery took over the front part of the building that had held the Old Town Pizza on Martin

Luther King Boulevard. Adam is a great businessman with lots of vision, but he is not a brewer. Thankfully, since it opened, Old Town Brewing has attracted very gifted brewers.

The Brewers

Scott Guckel opened Old Town Brewing before moving on to work with his good friends at Gigantic Brewing. Next up was Bolt Minister, who built on the solid foundation that Scott had laid.

Under Bolt's leadership, Old Town Brewing won a number of medals, including a bronze and a silver at the World Beer Cup and a gold and silver at the Great American Beer Festival. In early December 2014, Bolt left Old Town to start his own brewery across the river in the Vancouver area: 54° 40' Brewing Co. That leads us to the current Old Town Brewing team of Cory McGuinness and Andrew Lamont.

Cory McGuinness grew up in Eugene, Oregon, and his beer journey started when he began homebrewing at eighteen years old. He loved brewing and could not wait until the day he turned twenty-one and could become a brewer. The very week that he turned twenty-one, Cory started brewing at Ten Barrel in Bend.

A year later, Cory went to the Seibel Institute and studied brewing in both Chicago and Germany. Cory then worked at Tall Grass Brewing Company in Manhattan, Kansas, and Walking Man Brewing in Stevenson, Washington, before coming to Old Town Brewing. Cory loves the creativity that comes with brewing craft, and I suspect that he will have a hand in developing many new Old Town beers.

Andrew Lamont grew up in Mamont, Pennsylvania, and he attended Penn State, where he studied plastic mechanical engineering. Following college, Andrew went to work in the automotive industry. He moved to Detroit, Michigan, where he became a product design engineer.

During a visit home to Mamont, Andrew was talking with his friend Doug, who told him that you could brew beer at home and said it would be really cool if they did that together sometime. Andrew was stunned. He said, "You can brew beer at home?" Andrew asked for a homebrewing kit for Christmas and began brewing.

Andrew decided to pursue both his master's degree and his PhD. He enrolled at the University of Southern Mississippi–Hattiesburg and began studying large molecular organic chemistry. While living in Hattiesburg,

Cory McGuinness, Adam Milne and Andrew Lamont of Old Town Brewing Co.

Andrew came across a couple good places to drink beer: the Thirsty Hippo, a bar in downtown Hattiesburg with a great selection of craft beer, and Nick's Ice House, a dive bar on Hardy Street.

As Andrew studied large molecular organic chemistry during the day and enjoyed the occasional craft beer at night, he began to realize that he wanted to make beer for a living. He got his master's degree and moved on to the next chapter in his life. Andrew went to the University of California–Davis and completed its eighteen-week Master Brewers Program and passed the Institute of Brewing and Distilling (IBD), London, Diploma in Brewing Examination, aka the IBD Examination. Adam then got a job working for Boston Brewing Company at its Cincinnati brewing facility.

Andrew worked for Boston Brewing Company from 2006 to 2014. During his time with the company, he eventually moved to Boston and began working as an assistant brewer there. He later became the brewmaster of the Boston Brewing Company's research and development brewery.

In 2013, Andrew and his wife took a trip to the Northwest. They flew to Seattle and spent a few days there, and then they took the train down to Portland, Oregon. They checked into their hotel and began to look for a

place to eat. They came across Old Town Pizza and had dinner there. Both of them loved Portland.

By the spring of 2014, Andrew and his wife were ready to make a change, and they decided to move to Portland. By August 2014, Portland was home. Andrew was confident that he would easily find a job brewing, but as he began to talk with people in Portland, he found out his impeccable resume was a hindrance. While no one came right out and said it, it was clear to Andrew that many people saw him as overqualified.

Andrew had really enjoyed his time working for one of the largest American-owned breweries in the United States, and now he wanted to work for a craft brewery in Portland. He was sure that his experience and talent would make him an asset somewhere. In late December 2014, Andrew saw a job posting in the classifieds section on probrewer.com for a brewing position at Old Town Brewing. He e-mailed in his resume and references.

Adam and Cory were both delighted to welcome Andrew to the Old Town Brewing team, and he started there the first week of January 2015. Andrew had finally found his job working as a brewer in a Portland craft brewery.

I am quite certain that Old Town Brewing is a Portland brewery that you will want to keep your eye on over the few years. I am very excited to see how its story continues to unfold.

• SASQUATCH BREWING CO. •

"Three Years Later, I Opened a Brewery"

In the summer of 2014, I was at Cider Summit PDX at Fields Neighborhood Park visiting with Christopher Pierce and his awesome wife, Huma, and talking about this very book that you are reading. Marco Antonia Murray overheard our conversation and came over and said with much conviction, "You have to come out to Sasquatch Brewing and check us out. We would be a great fit for your book!" A few months later, I did that very thing. Marco was so right! Here is the Sasquatch story.

From Tugboats to Pagers to Beer

Tom Sims started out in the marine industry. He worked for a shipyard and then a tugboat company. He was a welder, an estimator and an engineer. Tom then spent many years running a paging company that he owned. You know: pagers. Apparently even in this decade, that was still a thing. Some of my readers may not even know what pagers are.

In 2008, Tom began homebrewing, and three years later, he opened Sasquatch Brewing. Tom had been homebrewing for one year when his wife, Karen, had a birthday party with many of their friends in attendance. Tom brewed the beer for that party, and he got many accolades for his beer. He had been thinking about a career change, and when that party was over, he decided that he was going to open a brewery.

Tom began buying and collecting commercial brewing equipment and storing it in a warehouse. Along the way, he was introduced to Alex Beard, and together they began looking for a location. Today, Alex is the general manager of Sasquatch Brewing. A lot of time was invested working on a potential location out in the St. John's neighborhood of Portland. That location fell through.

They did, however, find a location in the Hillsdale neighborhood of Portland on SW Capitol Highway, one mile from Tom's home. They signed a lease in August 2011 and opened in October of that year. Tom was convinced that everything that he had done professionally up until that point had prepared him to succeed as a brewer. He knew that you had to make great beer, and he also knew you have to be able to run a business. Sometimes when people want to open a brewery, they forget that part.

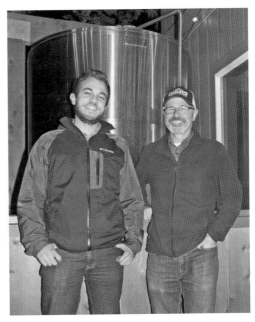

Alex Beard and Tom Sims from Sasquatch Brewing Co.

Portland Beer Stories

The Name

Tom and Alex chose the name in honor of the legendary Northwest iconic mystery known as Bigfoot or, if you prefer, Sasquatch. They see themselves to be very much like Bigfoot. They go about their business knowing that some people believe in them, and some people don't.

The Food

The food at Sasquatch is so good, and that is all because of Lauren Miller. Lauren grew up in Murray, Kentucky, and in the summer of 2009, she followed Phish across the country. One of the tour stops was in Portland, Oregon. Lauren was here two days, and she fell in love. She vowed that she would someday come back and make this magical place her home.

Lauren did eventually moved to Portland, and she attended the western Culinary Institute, where she heard of two guys looking for an executive chef for their new brewpub. Lauren prepared a menu that she thought would be awesome at a brewpub. This menu married the food she enjoyed growing up in Kentucky with all of the amazing local produce and ingredients that we are blessed to have here in Portland.

Lauren met with Tom and Alex, and they began to share the possible menu that someone else had prepared for them. This menu featured stereotypical pub food and involved pulling items out of the freezer and putting them into a deep fryer. Lauren had no interest in doing this, so she kindly ended the meeting without even going over the menu she had brought.

What Lauren did not know was that Tom and Alex were not at all attached the sample menu that they had shared with her. Thankfully, when she left the table, her menu got left behind, and Tom and Alex found it a little while later. They loved her ideas, and they called her and hired her right then.

When you go to Sasquatch, you will enjoy wonderful beer, but you really need to plan on having a meal while you are there as well. The fried chicken is amazing, the beet fritters are a revelation and you can't do much better than a glass of Sasquatch Woodboy Dry-Hopped IPA and some of Lauren's Deep Fried Kimchee Pickles.

Marco Antonia Murray, who led me to Sasquatch in our initial conversation, has been with the brewery since day one. He started out as Lauren's sous chef, and now he is the restaurant manager. I am very glad that I met him while enjoying cider on that beautiful summer day in 2014.

· STORMBREAKER BREWING ·

"I Will Wash Kegs Until You Make Me a Brewer"

Rob Lutz and Dan Malech opened StormBreaker Brewing on February 1, 2014, realizing a dream that each of them had had for many years. They are both native New Yorkers who grew up about thirty miles apart.

Rob is from Poughkeepsie, and Dan is from Tarrytown, but they did not meet until they both moved to Portland in the same year: 2006. They met at a now-closed sports bar in downtown Portland watching Jets games, since both Dan and Rob have the misfortune of being New York Jets fans. For their sakes, I hope that Gary Vaynerchuk is someday able to fulfill his dream of buying the Jets.

Rob's Road to StormBreaker

Rob drank a lot of beer while attending Binghamton University. Bottle collecting became a hobby, and that led him to Sam the Beer Man, a local bottle shop where he found lots of beers that he had never heard of. Following college, Rob got a job at Half Time, a beer distributorship in Poughkeepsie. It was there that Rob decided that he wanted to be part of the beer business and own his own brewpub or beer bar.

Ron followed a friend to Portland. He had heard that Portland was becoming *the* place for craft beer, and he wanted to be at the center of the action. Once he got to Portland, Rob went to work at Point Blank Distributing, becoming its ninth employee. Rob was there for a year and half. He was determined to get to know the beer business, so he took a night job bartending at Concordia Ale House.

Rob's next step was to get on at a brewery and work his way into a brewer position. Rob applied to be a keg washer at Laurelwood, but they would not hire him. Rob was told that it was too hard a job and that they wouldn't give it to him.

Rob then bugged Kevin King, owner of Amnesia Brewing, to hire him and make him a keg washer. Kevin did hire Rob, with the stern warning that being a keg washer was an awful job and that Kevin had had people walk out in the middle of their first shift. Rob told Kevin that he was going to be a keg washer until they made him a brewer.

Rob did end up becoming an assistant brewer at Amnesia. One fateful day in 2013, Kevin said to Rob, "Would you like to buy this place?" Kevin

was moving Amnesia across the river to Washougal, Washington, and Rob was given the chance to take over the lease and buy the brewing equipment on which he had been brewing for the past five years.

Dan's Road to StormBreaker

Following college Dan took a corporate job in Atlanta. While in Atlanta, Dan visited Sweetwater Brewing a number of times, and those visits changed his perspective on brewing and on beer. Dan was then transferred to Denver, where, to quote him, "[his] craft beer eyes were really opened."

It was in Denver that Dan began to think about working in the beer business. Dan was then transferred to Portland in 2006, where he met Rob while cheering on the Jets at the City Sports Bar in downtown Portland. By 2007, Dan's interest in the beer business had grown to the point that he decided that somehow, some way, he was going to work full time in the beer business and open up a brewpub or a beer bar.

Dan Malech and Rob Lutz from StormBreaker Brewing.

Ten More Portland Brewer Stories

In 2008, Dan said to Rob, "How about you and I open up a beer bar?" Dan said that he was not ready yet to do that but that in a few years he would love to go into business with Dan.

The Phone Call

Five years later, Dan received a call from Rob telling him to come down to Amnesia right away because they needed to talk. Dan remembers being nervous and wondering what Rob was going to tell him. Rob asked him, "How would you like to buy this place with me?"

They took possession of the building on January 1, 2014, and began brewing beer and doing a major remodel. Thirty days later, StormBreaker Brewing opened on February 1, 2014.

The Name

The name of the brewery was their toughest decision. They wanted a name that was both local and/or weather related. In the summer of 2013, while they were talking about names, Dan remembered a book that he had read years ago. *Night Dogs* by Kent Anderson is a detective novel set in Portland. In that fictional book, there is a passage that said that an old nickname for Mount Hood was "Stormbreaker" because it could split a storm in half. As soon as Dan suggested StormBreaker, Rob gave it a thumbs up, and they finally had a name for their brewery.

Beer and Whiskey

One of great things on the menu at StormBreaker is the beer and whiskey pairings. You get a shot of whiskey and a half pint of beer. My favorite is the Black Ghost pairing, a shot of Ghost Owl Pacific Small Batch Whiskey and a half pint of StormBreaker's Opacus Oatmeal Stout. My friend Frank Rinaldi was the person who turned me on to the beer and whiskey pairings at StormBreaker, and I am very glad that he did.

Each winter, StormBreaker hosts Brewstillery, a beer and whiskey pairing festival matching up local beers with local Northwest spirits.

A beer and whiskey pairing from StormBreaker Brewing.

StormBreaker is an awesome brewery. When you go there you will find wonderful beer, great food, a very charming outdoor fire pit and excellent outdoor seating. As Dan and Rob will tell you, in Portland, beer dreams do come true.

• UPRIGHT BREWING •

"I Loved Brewing Even More Than I Thought"

Alex Ganum opened Upright Brewing in March 2009 in the basement of the Left Bank Annex. In December 2010, he opened the Grain and Gristle Pub, and in 2013, he opened up the Old Salt Marketplace.

Alex Ganum from Upright Brewing.

From Detroit to Portland

Alex grew up in Detroit, and once he turned twenty-one, he enjoyed the Michigan craft beer scene. Some of his favorite Michigan breweries included Founders, Bell's and New Holland. It was Alex's dad who taught him to enjoy good-quality beer.

In 2002, Alex moved to Portland to attend culinary school at Western Culinary Institute. As soon as Alex got to Portland, he met a number of homebrewers, and he began homebrewing, even while he was in culinary school.

A Life-Changing Internship

Toward the end of culinary school, Alex needed to go somewhere for an internship. Ray Colvin was the person at Western Culinary Institute who approved where students took their internships. Alex remembers going into Ray's office and asking if he could do his internship at a brewery. Alex was not sure if this request would be approved, but Ray had no

problem with this, and Alex began looking for a brewery at which to do a short internship.

On a side note, Ray Colvin is now with the Oregon Culinary Institute (OCI), and you can read the OCI story in my first book, *Portland Food Cart Stories*.

Alex sent out dozens of letters looking for a brewery that would let him come do an internship. Ommegang—a brewery in upstate New York, outside of Cooperstown—invited Alex to come out. Alex spent three life-changing months there that fall. While there, he found that he loved brewing even more than he thought that he would, and by the time that his internship was complete, he knew that brewing was what he wanted to do with the rest of life.

Alex came back to Portland, gradated from culinary school, returned to his old job at Belmont Station and began looking for a job as a brewer. Alex ended up working as a brewer at BJ's Restaurant & Brewhouse on Jantzen Beach in Portland, but in 2006, he left there and began planning to open Upright.

The Name

While Alex was still in Michigan, he lived for a year or so in East Lansing, home of Michigan State University. Alex's friend Geoff was attending the music school there, studying violin performance. Geoff turned Alex on to jazz music, and that led to Alex finding and loving the music of Charles Mingus, which leads us to the name of Alex's brewery.

The name Upright Brewery is a tip of the hat to the upright bass that Charles Mingus often played. Alex believes that the music of Charles Mingus does not fit into any conventional category. As he puts it, "Mingus was totally unbound." That is the approach that Alex takes with brewing. Alex thinks that people should not worry so much about what the style of a beer is and just enjoy it. Lots of people do just that: they simply enjoy Alex's beer.

Make your way down to the basement sometime, and check out the Upright tasting room. The hours are limited, and it is not the easiest tasting room to find, but it is a great little space that even has a record player. You can a have great beer and enjoy some wonderful music, and if you like, you can even walk around the brewery and check that out.

Alex marches to beat of a different drum, and the Portland beer community is better because he chose to make Portland his home and share his beer with us.

· WIDMER BROTHERS BREWING ·

It's Pronounced "Hayfa-vy-tsen"

Rob and Kurt Widmer opened their brewery in 1984. By 1986, there were four breweries in the city of Portland: Widmer Brothers Brewing, McMenamins Hillsdale Brewery, Bridgeport and Portland Brewing. Rob and Kurt remember wondering if Portland could support all four of those breweries. Things have certainly changed.

According to the Oregon Brewer's Guild, at the end of 2014, there were fifty-eight breweries in the city of Portland itself and eighty-three breweries in the Portland Metro Area. Portland has more breweries than any other city in the world. Needless to say, here in Portland, we like beer.

For those who are wondering, the Oregon Brewer's Guild says that by the end of 2014, there were 221 breweries scattered across the state.

Rob and Kurt Widmer.

Brian Yaeger's excellent book *Oregon Breweries* covers every corner of Oregon and features 192 different breweries. It's a great read. If you like *Portland Beer Stories*, you will enjoy *Oregon Breweries*.

We Could Outwork Anyone

It was Kurt who asked Rob to move back to Portland from Seattle so that the two of them could open a brewery together. I asked Kurt why he wanted his brother as a partner. Failed partnerships are common, and failed businesses started by family members are even more common. Kurt said that he knew Rob's work ethic matched his and that the two of them could outwork anyone. If you are going to succeed, you need to work hard and pay the price if you are ever going to live the dream.

They Had to Hustle

Kurt and Rob's first business plan was to have a brewpub and ten other accounts. To make even that happen, they had to hustle. They had to make the beer, and then they had to go sell it. They would load kegs into their little pickup and drive around town trying to sell their beer.

People were very skeptical. Kurt and Rob would often hear something like this: "So you guys want me to buy this beer that you will deliver, and you two are the ones who made it? Is all of that even legal?" Others would say, "I don't want to be a pioneer. Once my customers start asking for your beer, I will put it on tap."

Rob and Kurt worked very hard. Rob remembers getting home late on many nights, walking in the door and going straight to bed because he was too tired to do anything else. Kurt said that many nights they would simply sleep in the brewery because it was so late that it did not make any sense to go home. But the brothers knew that if your startup is going to succeed, you have to work hard, and you have to tell your story.

If your story is authentic and compelling, and you keep telling it, and you don't quit doing that, people will become interested in it. Some of those people will start following your story. Some of those followers will become passive fans, and some of those passive fans will become passionate fans, and *they* will help you tell your story.

Ten More Portland Brewer Stories

Rob and Kurt kept telling their story. and they got some passive fans when places like the Horse Brass and Produce Row started putting their beer on tap. In Carl Simpson, they found their first passionate fan. Carl owned the Dublin Pub, which was on 20th and Belmont at the time. Carl loved their beer, and he had both of their beers on tap: an altbier and a weizenbier.

Rob remembers one day early on when he spent all day getting doors slammed in his face. That day it seemed like nobody wanted their beer. Rob was very discouraged when he headed back to the brewery. Late in the day, Carl called up and ordered four kegs. That was a huge sale, and it came at just the right time.

Carl kept asking Kurt and Rob to make a third beer so that he could put another Widmer beer on tap. They brought him a keg of Hefeweizen. People were not sure that they wanted to drink a cloudy beer, but Carl told people that it was supposed to look like that, and he gave out samples. Carl also served the beer in a "proper glass" with a lemon. As Rob put it, "Carl's presentation of our beer was wonderful."

The Beer That Changed Craft Beer in America

When Rob and Kurt started making their cloudy Hefeweizen, the standard and the expectation was that beer was supposed to be "polished" and clear. If your beer was cloudy, there must be something wrong with it. Today, across America, people drink cloudy beer without ever giving it a second thought, but that was not always the case.

There is a whole generation of people here in Portland who grew up drinking "polished" beer, who clearly remember the very first time that they had a Widmer Hefeweizen. For many of them, it was the first time they ever had a craft beer, and it was definitely the first time they ever drank a cloudy beer. I have heard this story many times over. Here is one of those stories.

You're Drinking That?

In 1989, Susan Henley DeMara came to Portland to attend Western Culinary Institute. One evening, Susan and her classmates went out for a beer. Up until that night, the only beer that Susan drank was Coors Light, but the bar was out of Coors Light. The bartender told her, "Let me get you a Hefeweizen."

Widmer Hefeweizen.

Susan was served a cloudy beer with a lemon on the side of the glass, and she said to herself, "That is a strange-looking beer." Susan very tentatively tasted it, and much to her surprise, she loved it. That beer "changed [her] beer drinking life." From then on, she began trying and enjoying many other craft beers.

Soon after, Susan took her husband, Dyson, to that bar. She told him that he had to try this beer that she had found. Dyson was very curious about this beer. For years, Dyson had tried to get to Susan to drink beers other than Coors Light, and he had always failed in those attempts. When the Hefeweizen arrived, Dyson exclaimed, "*You* are drinking *that?*" He could not believe how much this beer had changed his wife. Once Dyson tasted it, he understood.

By the way, the proper pronunciation for this beer is "hayfa-vy-tsen." How do I know this? That is what Kurt and Rob told me.

A Perfect Summer Day

In Portland, we are blessed that both the mountains and the ocean are so close. I love to go to the Oregon coast. My favorite Oregon state park is Cape Lookout, just south of Tillamook. For me, there are few things better than ending a summer day at the Oregon Coast by lighting a campfire on the beach as dusk is approaching and roasting a hot dog on that campfire. Take that roasted dog, put some mustard on it and enjoy it with a cold Hefeweizen while you watch the sun set. That is the good life.

Appendix I
OTHER NORTHWEST BEER BOOKS

For additional reading, here are some excellent books about beer in the Northwest:

Abernathy, John. *Bend Beer*. Charleston, SC: The History Press, 2014.

Cizmar, Martin, ed. "Willamette Week's Portland Beer Guide." Published annually. http://www.wweek.com/portland/beerguide.

Dunlop, Pete. *Portland Beer*. Charleston, SC: The History Press, 2013.

Morrison, Lisa. *Craft Beers of the Pacific Northwest*. Portland, OR: Timber Press, 2011.

Yaeger, Brian. *Oregon Breweries*. Mechanicsburg, PA: Stackpole Books, 2014.

Appendix II
GREAT BEER PLACES TO VISIT CHECKLIST

L isted in the order that they are featured in *Portland Beer Stories*

_ Base Camp Brewing, Portland
_ Breakside Dekum Pub, Portland
_ Breakside Milwaukie Brewery and Tasting Room, Milwaukie, Oregon
_ Raccoon Lodge & Brew Pub, Portland
_ Cascade Brewing Barrel House, Portland
_ The Commons Brewery, Portland
_ Culmination Brewing, Portland
_ Doomsday Brewing, Washougal, Washington
_ Ecliptic Brewing, Portland
_ Gigantic Brewing, Portland
_ Ground Breaker Brewing, Portland
_ FH Steinbart, Portland
_ Fort George Brewing, Astoria, Oregon
_ Ale Apothecary, Bend, Oregon
_ Rogue Ales Public House, Newport, Oregon
_ Rogue Distillery and Public House, Portland
_ Rogue Hall, Portland
_ Green Dragon, Portland
_ Chatoe Rogue Tasting Room and Rogue Farms, Independence, Oregon
_ Pelican Brewing, Pacific City, Oregon
_ Hair of the Dog, Portland

APPENDIX II

_ Kells Pub, Portland
_ Kells Brewpub, Portland
_ Laurelwood Public House & Brewery, Portland
_ Laurelwood SE Public House, Portland
_ Lompoc Tavern Portland, Portland
_ Lompoc Hedge House, Portland
_ Lompoc Oaks Bottom Public House, Portland
_ Lompoc Fifth Quadrant, Portland
_ LomPoc SideBar, Portland
_ McMenamins Barley Mill Pub, Portland
_ McMenamins Hillsdale Brewery and Public House, Portland
_ McMenamins Edgefield, Troutdale
_ Upright Brewing, Portland
_ Widmer Brothers Brewery Tour, Portland
_ Widmer Bothers Pub, Portland

PORTLAND BEER FESTIVALS AND EVENTS CHECKLIST

I n chronological order.

_ Collabofest
_ NW Coffee Beer Invitational
_ Artisanal Portland Beer and Chocolate Festival
_ Zwickelmania
_ Festival of the Dark Arts
_ Brewstillery
_ Black Out Fest
_ Tart Fruit Fest
_ Malt Ball Portland
_ Cider Rite of Spring
_ Portland Farmhouse and Wild Ale Festival
_ Portland Spring Beer and Wine Fest
_ Baker's Dozen Coffee Beer and Donuts Festival
_ Smoky & Dank Beer Fest
_ Cheers to Belgian Beers
_ PDX Beer Week
_ Portland Fruit Beer Festival
_ Rye Beer Fest
_ Portland Beer & Cheese Festival
_ Cider Summit NW
_ Portland International Cider Cup
_ Oregon Cider Week

_ Oregon Garden Brewfest
_ Portland International Beerfest
_ July Oregon Craft Beer Month
_ Portland Craft Beer Festival
_ LagerFest
_ Puckerfest
_ Oregon Brewer's Festival
_ North American Organic Brewers Festival
_ Bend Brewfest
_ Hood River Hops Fest
_ Widmer Oktoberfest
_ Handmade Bike and Beer Festival
_ St. Paul Fresh Hop Festival
_ Portland Fresh Hops Festival
_ Peche Fest
_ Killer Beer Week
_ Killer Pumpkin Festival
_ Killer Beer Fest
_ NW Ciderfest
_ Portland CDA Festival
_ Holiday Ale Festival
_ Christmas Eve Eve

For more information on these and other Porltand beer festivals and events, go to www.PortlandBeerFestivals.com.

ABOUT THE AUTHOR

S teven is the author of *Portland Food Cart Stories: Behind the Scenes with the City's Culinary Entrepreneurs*. *Portland Beer Stories: Behind the Scenes with the City's Craft Brewers* is his second book.

Steven's current literary project is *Spark to Bonfire: How Branding, Marketing, and Social Media Can Ignite Your Idea*. In the summer of 2015, he will write his third culinary book: *Oregon Wine Stories: Behind the Scenes with the State's Winemakers*, which is slated for publication in the spring of 2016. He is a member of the North American Guild of Beer Writers.

Steven is the host of the *Tasty Tuesday* radio show on Portland Radio Project 99.1 FM, which airs every Tuesday from 7:00 to 10:00 a.m. Each Tuesday at 9:00 a.m., he has a culinary guest join him in the studio for a live interview.

Steven is the festival coordinator for the Portland Spring Beer and Wine Fest, the largest spring beer festival in the United States. He has been part of the Portland Spring Beer and Wine Fest team since 2014. He is one of the co-founders of the Portland Summer Food Cart Festival, and he was an organizer of that event in 2013 and 2014.

Steven has previously worked more than ten years in mortgage banking and more than ten years in the nonprofit world, including serving for a one and half years as the chaplain for the Cityteam Portland rescue mission and homeless shelter, working with the homeless population in downtown Portland.

You can follow Steven's adventures at www.StevenShomler.com, and he can be found on Facebook, Twitter and Instagram.